An Interlude in Giverny

Joyce Henri Robinson
Derrick R. Cartwright

With an essay by E. Adina Gordon

Palmer Museum of Art
The Pennsylvania State University
University Park, Pennsylvania

Musée d'Art Américain Giverny
Terra Foundation for the Arts
Giverny, France

Front Cover: Frederick William MacMonnies, *The French Chevalier*, 1901 (left)
Mary Fairchild MacMonnies, *Dans la nursery*, c. 1896-98 (right)

Back Cover: Will Hickok Low, *L'Interlude: Jardin de MacMonnies*, 1901

Opposite: *MacMonnies Family*, c. 1901. MacMonnies family papers.
Photograph courtesy of E. Adina Gordon

Published on the occasion of the exhibitions:

An Interlude in Giverny: The French Chevalier *by Frederick MacMonnies*

Palmer Museum of Art
October 24, 2000 – February 25, 2001

Musée d'Art Américain Giverny
April 1 – June 24, 2001

An Interlude in Giverny: Dans la nursery *by Mary MacMonnies Low*

Musée d'Art Américain Giverny
April 1 – June 24, 2001

Designed by Catherine H. Zangrilli
Printed by Nittany Valley Offset, State College, Pa.

This publication is available in alternative media on request.

ISBN 0-911209-52-2
Library of Congress Control Number 00 092772

Table of Contents

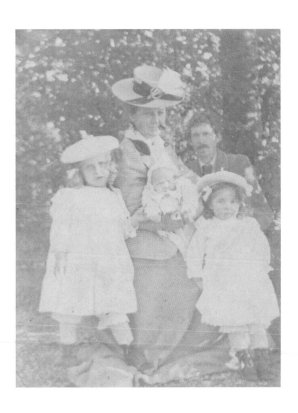

Acknowledgments
page 5

An Interlude in Giverny: *The French Chevalier* by
Frederick MacMonnies
JOYCE HENRI ROBINSON
page 7

Beyond the Nursery: The Public Careers and Private
Spheres of Mary Fairchild MacMonnies Low
DERRICK R. CARTWRIGHT
page 35

The Expansion of a Career: Frederick MacMonnies
as a Teacher and Painter
E. ADINA GORDON
page 59

Checklist of the Exhibition
page 87

This exhibition has benefited from the help of many individuals, both in Europe and in the United States. I would like to take this opportunity to thank them. In the United States, E. Adina Gordon, Kristin H. Lister, Kirstin Ringelberg, David Sellin, and Mary S. Smart all took time out of busy schedules to discuss their interests in Mary Fairchild MacMonnies Low with me. Additionally, Barbara Bishop, Archives of American Art, West Coast Regional Center; Verna Curtis, Library of Congress; Laurette E. McCarthy and Elizabeth Petrulis, Sheldon Swope Art Museum; Marianne Richter, Union League Club of Chicago; and Cathy Ricciardelli, Tom Skwerski, and, especially, Shelly Roman, Terra Museum of American Art; shared their considerable expertise on this subject. In England, Wing Commander J. R. Myers, Junior Bursar at Robinson College, Cambridge University, provided information about an important work at his institution. In France, Jean-Marie Toulgouat, Claire Joyes, and Danièle Foreau all took deep interest in this project, as did Claude Petry, Musée des Beaux-Arts, Rouen, and Sophie Fourny-Dargère, Musée Municipal A.-G. Poulain, Vernon. The staff at the Musée d'Art Américain Giverny deserves special credit for their contributions to the exhibition, of course. In particular, I wish to thank Bronwyn Griffith, Véréna Herrgott, Maureen Lefèvre, Sophie Lévy, Géraldine Raulot, Véronique Roca, and Francesca Rose. Finally, I gratefully acknowledge the support of the Terra Foundation for the Arts, whose enthusiasm for the study of turn-of-the-century expatriate artists, such as Frederick and Mary MacMonnies, has made the exhibition in Giverny possible.

Derrick R. Cartwright
Director, Musée d'Art Américain Giverny

An Interlude in Giverny would not have been possible without the enthusiastic cooperation of many individuals. Special thanks are due to Mr. and Mrs. Melvin S. Frank, who generously donated *The French Chevalier* by Frederick MacMonnies to the Palmer Museum of Art in 1997. Jan Keene Muhlert, director at the Palmer, planted the idea for a small contextual exhibition early on and offered sage advice from the outset. The staff of the Palmer Museum of Art also deserves recognition, especially Beverly Balger, registrar, who handled the details of international travel with ease and clear thinking. Robin Seymour, graduate assistant, ably maneuvered the often-bewildering logistics of rights and reproductions and was an indefatigable researcher. Our conversations about MacMonnies were critical to the formulation of my catalogue essay. The exhibition is indebted to the generous support of the lending institutions, galleries, and private collectors. For their help in facilitating loans, I would like to acknowledge H. Barbara Weinberg, curator of American Painting and Sculpture, The Metropolitan Museum of Art; Marianne Richter, curator, Union League Club of Chicago; George E. Mazeika, former registrar, The William Benton Museum of Art; James Berry Hill and Frederick Hill, Berry-Hill Galleries, Inc.; Robert D. Schwarz, Schwarz Gallery, Philadelphia; and Suzanne Foley, curator, and Jean Collier, registrar, Bayly Art Museum of the University of Virginia. Eric W. Baumgartner, Hirschl and Adler Galleries; Gerald Peters Gallery, Sante Fe; Shelly Roman, Terra Museum of American Art; Toni Hulse, registrar, The William Benton Museum of Art; Christopher Foote; Julia Moore Converse; Anne Moore; Donald Purdy; and Glen Peck provided assistance in the procuring of photographs. Marcie Karp at The Metropolitan Museum of Art helped with a last-minute research question. Finally, my sincerest thanks go to E. Adina Gordon, who graciously opened her research files and her home to me and willingly lent many photographs for this publication. Her pioneering research of both the sculpture and painting of Frederick MacMonnies laid the foundation for this exhibition and catalogue.

Joyce Henri Robinson
Associate Curator, Palmer Museum of Art

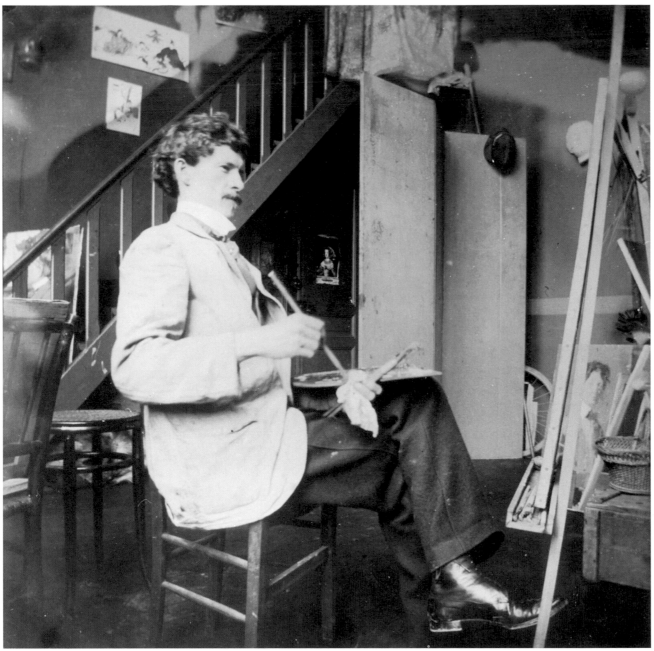

Figure 1 *Frederick William MacMonnies*, c. 1901. MacMonnies family papers. Photograph courtesy of E. Adina Gordon

An Interlude in Giverny:
The French Chevalier
by Frederick MacMonnies

JOYCE HENRI ROBINSON

I have always wished to do a decoration and when you asked me to…I immediately decided to
do it myself. Now don't be frightened (I can paint as well as I can do sculpture).

Frederick MacMonnies to Stanford White, January 10, 1892

…The last thing in the world I am frightened about is your painting the ceiling *yourself.*

Stanford White to Frederick MacMonnies, January 19, 1892[1]

On October 15, 1900, the *New York Herald* ran an article informing its readership
of the imminent return to the United States of the world-renowned sculptor
Frederick William MacMonnies. Like most ambitious artists of his day,
MacMonnies had spent much of the previous fifteen years studying and forging a career
in Europe with intermittent visits to his country of birth. According to the artist's brother
Frank, the supposed source of the *Herald's* scoop, the instigation for MacMonnies'
return was in part the sculptor's recent shift to portrait painting "as a means of rest and
recreation." "He has always done some work with the brush," Frank noted, "but has
never exhibited a canvas." Indeed, concluded the proud sibling, "He is doing excellent
work with the brush and intends to exhibit some of his canvases."[2]

Despite the "late breaking" tenor of the *Herald* article, MacMonnies' interest in painting
was nothing new. As Pauline King would note a few years later, "from boyhood there
had ever been the desire to paint, and from time to time, practising [*sic*] with the brush
as a diversion, the handling of pigments had exercised a strong fascination over him."[3]
In late 1898, well before the October 1900 announcement, MacMonnies had alerted his

friend Stanford White of his intentions to put aside his sculptor's tools in favor of the brush, prompting his colleague to respond, "I do not know which to be most—glad that you are going into painting, or sorry that you are going out of sculpture."[4] And as the epigraph to this essay suggests, White by that time had already learned of MacMonnies' prowess as both a sculptor and a painter.

Although MacMonnies decided against taking up residence in New York in late 1900, his stated intention to turn to painting with new vigor and purpose that year came to fruition in the early years of the new century (and was anticipated by several canvases completed in the late 1890s). Not surprisingly, MacMonnies' paintings are less familiar to students of American art than his prodigious successes in sculpture. The recent check-list of paintings compiled by E. Adina Gordon has done much to address this lacuna in the scholarship, though most of the one hundred or so paintings attributed to the artist remain in private hands, making it difficult for scholars to examine the painted oeuvre in depth.[5] *The French Chevalier*, painted in 1901 and now in the collection of the Palmer Museum of Art, is admittedly but one example—albeit, a monumental one—of MacMonnies' work from the turn of the century. Yet, it can be argued that the work is a kind of "metaportrait," to borrow David Lubin's terminology, that is, a portrait *about* portraiture, or, at least, about the practice of painting.[6] Undoubtedly the artist's most complex canvas as well as his most ambitious self-portrait, *The French Chevalier* has much to reveal about MacMonnies' personal life, his ambitions as an artist, and his vision of himself within the history of art.

MacMonnies' nearly meteoric rise to fame as a young sculptor in the closing decades of the nineteenth century is by now a familiar story. Having demonstrated a penchant for modeling everything from pie dough and chewing gum to clay as a youngster in Brooklyn, MacMonnies became a studio assistant to the sculptor Augustus Saint-Gaudens in 1880 at the age of 16. Although it would take some time for the fractious and self-absorbed Saint-Gaudens to recognize the artistic talent of his young errand runner, MacMonnies was eventually elevated to the rank of apprentice. For two years, MacMonnies devoted himself to learning the rudiments of clay modeling and plaster casting in the bustling studio of the academically trained sculptor and also made the acquaintance of many of the great artistic personages of the day, including the architect Stanford White. Saint-Gaudens encouraged his talented protégé to pursue, as he had, further instruction at the world's most prestigious art school, the Ecole des Beaux-Arts in Paris. In the autumn of 1884, MacMonnies set sail for Europe, the ultimate destination for any ambitious art student in the nineteenth century.

Barely 21 years old, MacMonnies arrived in Paris armed with a formidable background in sculpture and letters of introduction from his mentor. Tellingly, three of the letters were addressed to leading painters of the day—Jules Bastien-Lepage, the muralist Paul Baudry, and the already notorious John Singer Sargent—indicating that the young

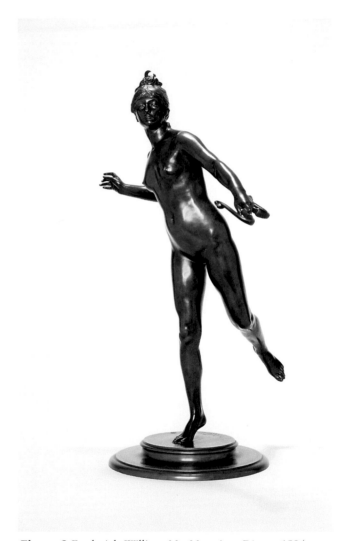

Figure 2 Frederick William MacMonnies, *Diana*, 1894 (original 1889). Bronze with golden patina, 30 1/2 x 20 1/2 x 16 1/4 inches. Terra Foundation for the Arts, Daniel J. Terra Collection, 1988.21. Photograph courtesy of Terra Foundation for the Arts, Chicago

MacMonnies may have entertained the notion of entering the atelier of a painter at the commencement of his academic training. For a variety of reasons, none of the three was available to meet with the young student "or [else]," as MacMonnies laconically recalled many years later, "I would have been a painter."[7] A cholera epidemic forced MacMonnies to leave Paris shortly after his arrival, and soon the young artist found himself enrolled in life drawing and anatomy courses at the Royal Academy of Art in Munich. During off-hours, the eager student immersed himself in the painting techniques of modern German artists and also tried his hand at oil painting by copying Old Masters at the Pinakothek. Throughout his training, as MacMonnies also later recounted, he always "painted on the sly."[8]

It was sculpture, however, that would occupy the thoughts of the artist during the next several years. In 1886 MacMonnies successfully completed the entrance exams to the Ecole des Beaux-Arts and was officially admitted to the atelier of the noted French sculptor Jean-Alexandre-Joseph Falguière. MacMonnies quickly distinguished himself as a student and twice received the *prix d'atelier*, the first prize in the semi-annual class competition. By 1888 MacMonnies had broken free from the rank of student and established his own studio. His *Diana*, 1889, is a facile example of the naturalistic, yet elegant Beaux-Arts style promulgated in the Falguière atelier (figure 2).[9] Awarded an honorable mention at the Salon of 1889, the *Diana* did much to establish MacMonnies' reputation. "The Salon at that time," the sculptor later remarked, "was the criterion. You could get a job on what you had won."[10] And jobs were indeed forthcoming. Commissions from private patrons, many of which were orchestrated through the architectural firm of McKim, Mead, and White, began to materialize in the late 1880s. The *Pan of Rohallion*, 1889-90 (see page 66), a fountain sculpture designed for the New Jersey summer home of Edward D. Adams, reveals the decorative grace as well as the neo-Florentine elegant contours and slender proportions that would typify the sculptor's most popular works in the coming years. Adams, a prominent New York banker, was obviously delighted with the results of the commission and soon placed orders for reductions to be given as gifts to friends. MacMonnies quickly recognized the marketing potential for parlor-scale editions of his larger pieces, including the infamous *Bacchante with Infant Faun*, 1893, and ultimately employed foundries in both New York and Paris to keep up with the demand (figure 3).

Work on two important public commissions in the early 1890s, the *Nathan Hale* for City Hall Plaza in New York and the monumental fountain for the World's Columbian Exposition in Chicago, 1893, occupied MacMonnies and brought him further fame. Much of the decade was devoted to major commissions such as these, which, while important for solidifying MacMonnies' already growing reputation, brought with them considerable headaches and expense. MacMonnies swore never again to take on a "temporary" piece after the nearly two-year expenditure of time, effort, and money on the multi-figural *Barge of State* for the 1893 exposition. As the turn of the century approached, however,

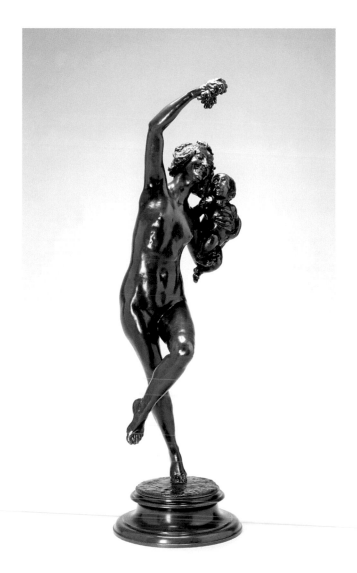

Figure 3 Frederick William MacMonnies, *Bacchante with Infant Faun*, 1894 (original 1893). Bronze with dark green patina, 34 3/4 x 11 1/2 x 11 1/2 inches. Terra Foundation for the Arts, Daniel J. Terra Collection, 1988.20. Photograph courtesy of Terra Foundation for the Arts, Chicago

the sculptor did send works to the 1900 Universal Exposition in Paris, including several plasters from the *Horse Tamers*, allegorically subtitled *The Triumph of Mind over Brute Force*, an ambitious group destined for Prospect Park in Brooklyn, the artist's hometown (installed 1899).

One wonders if the thought of an intellectual triumph over brute force was in fact on the mind of the sculptor as he contemplated a shift to painting at the close of the century. In the invaluable transcripts of the 1927 interview of the artist conducted by DeWitt M. Lockman, MacMonnies pointedly recalled at the time "suffering so from indigestion of sculpture and hard work, and scale proportion, and compassing, and casting that I had my belly full of it."[11] Earlier in the interview when discussing the artistic inclinations of his mother, the sculptor noted that she "wished this awful thing on me. I have had to work just like a bricklayer ever since."[12] More telling, perhaps, is the advice (admittedly tinged with fatherly concern and gender bias) that MacMonnies offered to his daughter Betty, who as a young woman considered taking up sculpture as a profession. "I'm simply broken backed—my hips feel as if they would drop off and my calves are leaden. Sculpture, my dear! Don't be a sculptor—no woman has ever succeeded in doing more than a frail beginning due to lack of strength…. Be a painter; you can accomplish on a canvas in an hour what it takes a week to do with clay—besides, after sculpture or with sculpture, painting is the most fascinating profession in the world."[13]

MacMonnies' desire to turn to this "most fascinating profession" was undoubtedly motivated in part, as his brother's comments to the press suggested, by a desire for "rest and recreation" after a decade of exhausting and backbreaking projects. Gordon's essay in this catalogue suggests that the sculptor's renewed interest in painting may also have been instigated by increased demands for his expertise as a teacher in the mid-1890s. Motivation for the shift to painting—in particular, portraiture—may also in part have been financial. MacMonnies often referred to painting as the more lucrative of the fine arts occupations and admitted to Lockman that had he entered a painting atelier upon his arrival in Paris as a student, he would "have plenty of money in the bank." In reporting his progress to Stanford White in 1901, MacMonnies noted, "Sculpture is not in it and will not see me for years—and as it now appears I will make lots of money. When I make enough I'll go back and do some sculpture."[14] To MacMonnies' mind, portraiture, unlike his monumental sculptural projects, was a leisurely and cost-effective pursuit. For many American painters at the turn of the century—James McNeill Whistler, William Merritt Chase, Cecelia Beaux, and John Singer Sargent, to name only the most outstanding examples—society portraiture was, as it were, money in the bank.

Whistler and MacMonnies, expatriates both, were colleagues and friends at this transitional period in the artist's career. The cosmopolitan Whistler was by this time, as Sarah Burns has argued, a kind of "maverick Old Master," admired for his considerable achievements yet still a pace-setter in bucking convention both socially and artistically

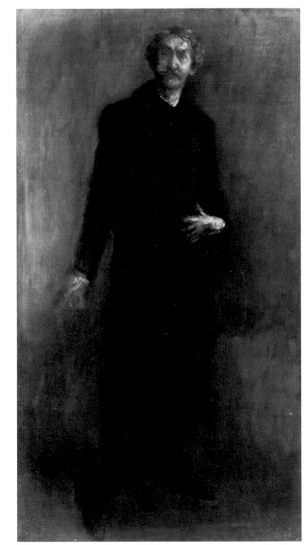

Figure 4 James McNeill Whistler, *Brown and Gold*, c. 1895-1900. Oil on canvas, 37 3/4 x 20 1/4 inches. Hunterian Museum and Art Gallery, University of Glasgow, Birnie Philip Bequest

(figure 4).[15] In the fall of 1898, the international press relayed the unexpected news that Whistler was preparing to open an art school in Paris. Downplaying his pedagogical role—a role that had always been antithetical to the *sui generis* artist, Whistler informed the press that indeed a school was being opened and "in company with my friend, the distinguished sculptor, Mr. MacMonnies, I have promised to attend its classes." MacMonnies later recalled that he was brought to the Académie Carmen, as the school became known, to "help [Whistler] out with teaching the sculptor pupils and the drawing," though it does appear that he, too, critiqued painting on occasion. MacMonnies, realizing that "the sculptor pupils did not arrive in droves" and that the atelier "had become a tonal modelling school," departed the studio amicably long before its official closure in 1901.[16]

During their association as master teachers, Whistler and MacMonnies often breakfasted together before studio visitations, and painting was likely an occasional topic of conversation. As Gordon has suggested, the friendship with Whistler may have instigated MacMonnies' 1898 trip to Spain to study the work of Velázquez. No doubt their association further encouraged the sculptor to pursue other artistic avenues.[17] It may be, too, that MacMonnies' summer trips in the 1890s to the quaint Normandy village of Giverny, which by the turn of the century was a well-known artistic colony for innumerable American impressionist painters, provided further fuel to his decision to take a sabbatical from sculpture.[18] MacMonnies, along with his wife, Mary Fairchild, a fellow art student and painter whom he had married in Paris in 1888, began visiting Giverny in the summer of 1890. A mere forty miles northwest of Paris just on the border of Normandy, Giverny was by this time also home to the reclusive Claude Monet. The town's real attraction, according to Will Hickok Low, painter, writer, and friend to the MacMonnieses, was its moisture-laden landscape bathed "in an iridescent flood of vaporous hues."[19] For young American painters in search of vaporous hues in the wake of the French Impressionist movement's success, Giverny offered both inviting vistas and a welcoming expatriate group of artists. The MacMonnieses—both Monsieur and Madame—would in time become the social focal points of that expatriate community.

In 1898 the MacMonnieses began renting and ultimately bought a centuries-old priory featuring a large house, terraced gardens, and several outbuildings suitable for conversion to studios. Many American visitors were treated to the natural beauty and picturesque charm of the property, and Mary's impressionist paintings from the period faithfully record the inviting serenity of the walled estate's cloistered gardens (see pages 49-51). Will H. Low and his wife, Berthe, indeed spent the better part of 1901 at the "MacMonastery," as it was dubbed, and Low's *L'Interlude: Jardin de MacMonnies* of that year is an idyllic homage to their extended stay (figure 5). For Low, who nearly a decade later would wed Mary Fairchild MacMonnies, the MacMonnies home was a kind of artistic paradise inhabited by convivial colleagues

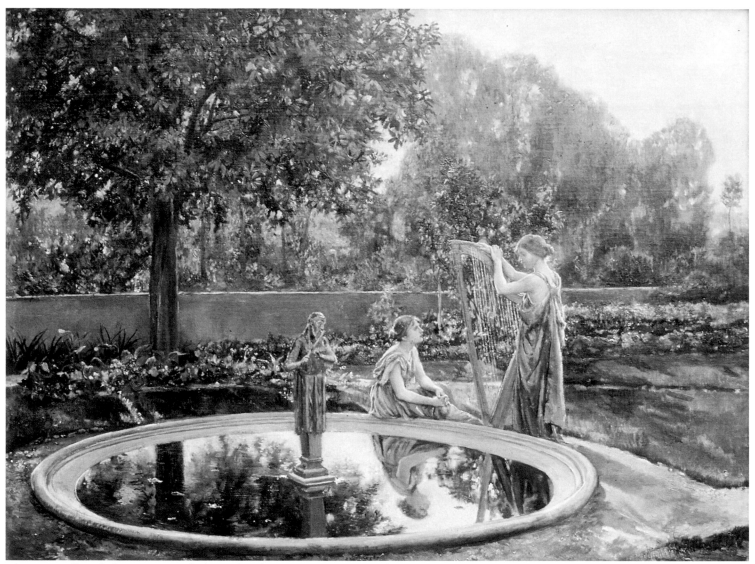

Figure 5 Will Hickok Low, *L'Interlude: Jardin de MacMonnies*, 1901. Oil on canvas, 19 1/4 x 25 1/2 inches. Bayly Art Museum, University of Virginia, Charlottesville

12

and enlivened by lengthy discussions of aesthetic matters. Frederick, now fully given over to painting, joined his wife and Low as they worked to capture the priory's quaint charm on canvas. "Not the least of the pleasures of the summer," Low wrote for his *Scribner's* readership in 1902, "was to see this skilful workman in a field new to him, yet one in which he was to a large degree master."[20]

Gordon's recently published checklist of the paintings of Frederick MacMonnies indeed confirms that by the summer of 1901 the artist was well on his way to "mastering" his ostensibly newfound art. Tentative beginnings in the form of portraits of family members and visiting students in the very late 1890s soon gave way to ambitious canvases produced at an astonishing rate. In October of 1901, MacMonnies happily informed his friend Stanford White that though he was temporarily short of cash and "sailing pretty close to the winds," he had "piles of orders for portraits" and was having the "time of [his] life." "I have 8 full-length portraits done since last January," he continued, "and some," he proudly noted, "are corkers."[21]

Madame la Comtesse de Trobriand, painted at this time and likely one of the works to which MacMonnies refers, is nothing if not a "corker" of a painting (figure 6). The American-born countess, who in her youth was said to have sat for Benjamin West (himself, interestingly, a distant relative of MacMonnies' mother), is shown holding court in her plush apartment on the Champs-Elysées. The *Comtesse* is clearly one of MacMonnies' most extravagant society portraits; every element in the beautifully furnished drawing room signifies the aged dowager's prominent social status. Many years after painting the grand lady, MacMonnies recalled that "about forty people a day used to come in and kiss her hand and talk scandal. She would say 'never mind my artist, he knows nothing.'" The magnificent portrait of the Comtesse de Trobriand (which, amusingly, his daughter Betty would later innocently record in a studio inventory as the "Comtesse de Trop Brilliant") was for the artist "quite a study, a human document of that lady in her time."[22]

According to Edith Pettit, who penned an important essay on the artist for the *International Studio*, MacMonnies' stated goal in portraiture was to paint a likeness that "is more like the sitter than the sitter himself."[23] In 1903, when a group of the artist's portraits was shown in New York at the Durand-Ruel Galleries, one critic for the *New York Tribune* noted that, "It is impossible for Mr. MacMonnies to leave his figures immobile, or in that environment which betrays the lifeless air of the studio. His portraits are brimming over with vitality...."[24] MacMonnies' full-length portraits from this productive period just after the turn of the century generally locate the sitter in appropriate social contexts. The males are shown in settings appropriate to their profession: the sculptor John Flanagan sits high atop a ladder in his cluttered studio, poised for work (*John Flanagan, Esq.*, c. 1901, The Newark Museum), while the Abbé Toussaint enacts the familiar ritual of the Mass alongside two distracted acolytes (see page 76). The portraits

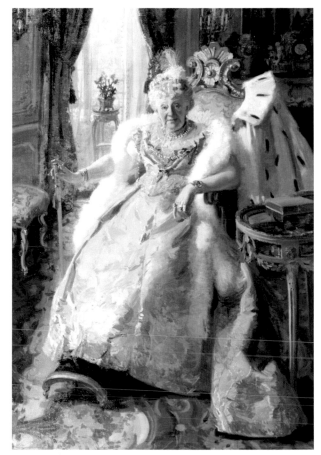

Figure 6 Frederick William MacMonnies, *Madame la Comtesse de Trobriand*, 1901. Oil on canvas, 80 3/4 x 56 1/4 inches. Hirschl and Adler Galleries, New York

of young women from this period, including the Terra Foundation's *Mabel Conkling*, 1904, position their elegant protagonists in more "natural" environs, reifying the age-old linkage of females and nature (see page 78). Set against a fecund backdrop, they are removed from the masculine realms of labor and finance and identified with a life of "natural" leisured privilege.

MacMonnies' attention to the details of setting in his portraits—whether natural or man-made—was generally applauded by contemporary commentators. According to critic Pauline King, in viewing portraits by the artist "we are made to realize the general characteristics, the thoughts, the aims of these people, what they stand for in life. Too often in modern painting the sitter is but a model; here are men and women."[25] MacMonnies, who recorded his thoughts on "The Beautiful Arts of Painting and Sculpture" in 1901, would have agreed with King's sentiments.[26] The unpublished essay, dictated to his pupil Mary Foote in the midst of his foray into portraiture, is in part a diatribe against "imagination" and a personal manifesto in support of the real as embodied in nature. "The true painter," MacMonnies writes, "is not the dreary creature of Imagination with his head in his hands congested with stuffy harmonies and absorbed in his own personality. But the gay lover who goes abroad and seeks his inspiration in nature far from the dusty studio, its weak dreams and threadbare traditions."[27] That the artist was at the time thinking in terms of such dichotomies—the real vs. the ideal, nature vs. studio, nature vs. imagination—is apparent in Low's above-mentioned, nostalgic article for *Scribner's* in which MacMonnies is identified as the "Uncompromising Realist" in contrast to Low's role as the "Idealist." "As the nearest approach to nature," Low writes, "all his work was planned to be."[28]

An important element of MacMonnies' espoused "realist" attitude to portraiture was the locating of the sitter in his or her appropriate environment, virtually anywhere, that is, other than the artificial confines of the studio. In the artist's manuscript on painting and sculpture, faithfully transcribed by his doting student, MacMonnies admonishes those painters who abrogate the fictive *mise en scène* of the realist portrait. "The painter, having brought his model out from her house and her accustomed surroundings…introduces her into the north lighted unnatural glare or, as the case may be, dim obscurity of the studio, totally foreign to the lady, [and] sits her down in a strange chair or stands her in a new perspective on a raised platform in an attitude he may have chosen well before he has studied his model." The ultimate result of such contrivance, MacMonnies concludes, is "no illusion of life whatsoever."[29]

This rather pointed attack against the artificial studio portrait might encourage us to question the motivation behind one of MacMonnies' first public successes, *Monsieur Cardin*, 1900-01, another of the artist's large canvases from the early years of his painting sojourn (figure 7). Awarded an honorable mention at the Salon of the Société des Artistes Français in 1901, this first of the artist's several "Salon" pictures certainly reads

Figure 7 Frederick William MacMonnies, *Monsieur Cardin*, 1900-01. Oil on canvas, 70 3/4 x 41 3/4 inches. Berry-Hill Galleries, New York

at a cursory glance as a "staged" portrait. An old actor with a copy of Emile Zola's *Fécondité* in hand is posed on a model's platform, his attention turned momentarily away from the artist (who presumably stands before him). What has caught his attention, it would appear, is the intrusion into this studio-like space of the artist's wife and second child, Marjorie. The room is quite well appointed with one of the family's several tapestries and copies after Botticelli by Mary Fairchild MacMonnies visible in the background. Also visible to the right of the canvas is a stately grandfather's clock, its presence seemingly indicative of a domestic rather than a work space. The canvas was exhibited under two different titles just after the turn of the century: for the 1903 Durand-Ruel show it was listed as *Monsieur Cardin*; however, two years earlier at the 1901 Salon it was entered as *Le Raseur* (The Bore). The latter was the title by which the artist remembered the picture many years later when he described to Lockman this "old actor who was in a studio on a platform and going through an act or something with a cloak half over him…."[30] This indeterminacy regarding the title of the picture, already present in the years immediately following its creation, suggests perhaps an uncertainty on the artist's part of how ultimately to categorize such a work—a highly contrived portrait of an individual set in a studio or an amusing character study of a "type"? And what are we to make of the two spectators in the picture, who, unlike the portrait's protagonist, gaze directly at the viewer? Does not their presence complicate matters by identifying the work as a kind of genre painting of everyday life in the MacMonnies household?

All of these questions might also be asked of the most complex (and equally indeterminate) painting of the artist's career, *The French Chevalier* (figure 9). This ambitious composition, which features a wide range of characters, made its first public appearance at the Durand-Ruel show in 1903 as *Monsieur Georges Thesmar*, and was shown at the Salon of 1906 under the title *Portrait de M.G.T.* It is clear that on one level the painting is a portrait of an identifiable figure, a certain George Thesmar, who, according to family lore, was godfather to the MacMonnieses' first child, Berthe Hélène, or Betty—the painting's other leading character. George was the son of André Fernand Thesmar, a respected enamelist who just a few years earlier had collaborated with MacMonnies on the exquisite and unique *Cupid*, 1898, now in a private collection (figure 8).[31] The elder Thesmar also appears in the painting, seated in the middleground alongside the glowing figure of the artist's wife and fellow painter, Mary Fairchild MacMonnies.

The present title of the painting, though still focused on the central figure, suggests that this work is far more than a straightforward depiction of a man in his "natural" environs; the cast of supporting characters and the domestic setting might also be enlisted as corroborating evidence. Much like *Monsieur Cardin*, the painting is essentially a costume piece set within the larger context of daily life at Le Moutier. Thesmar is impeccably dressed in the uniform of the *cuirassiers*, France's elite mounted-military corps that had been in existence at least since the Napoleonic era and continued to serve the country until 1914. The elements of the impressive and distinctive costume are faithfully tran-

Figure 8 Frederick William MacMonnies, *Cupid*, 1898. Ivory, hammered gold, lapus lazuli, marble, mahogany, bronze, 16 inches high (including base). Private collection

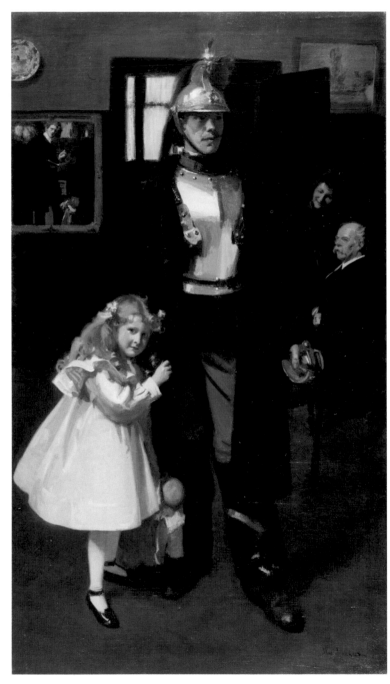

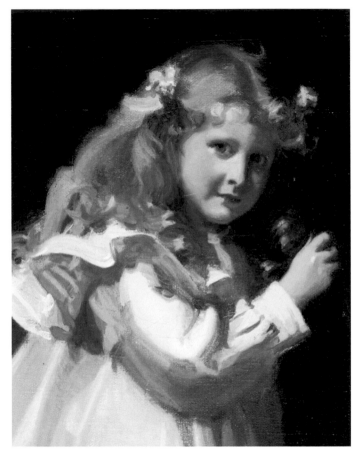

Figure 10 Frederick William MacMonnies, *The French Chevalier*, 1901 (detail)

Figure 9 Frederick William MacMonnies, *The French Chevalier*, 1901. Oil on canvas, 89 x 50 1/2 inches. Palmer Museum of Art, University Park, Pennsylvania. Gift of Mr. and Mrs. Melvin S. Frank

16

scribed, from the classically inspired helmet and gleaming *cuirass* or breastplate, to the riding breeches, shiny boots, and the half-basket sword. In 1927, many years after the work was completed, Betty would list the painting as "cuirassier and myself" in the studio inventory drawn up for her father. The choice of the character rather than the person for the title, especially if Thesmar was indeed her godfather, is telling. Betty's daughter, Marjorie M. Young, would even later in the century characterize the work as *Georges Thesmar, Chevalier*, a title signaling further the painting's problematic self-identity.[32]

Ultimately, the painting is clearly not so much *about* Monsieur Thesmar as it is about the artistic and social milieu awaiting the young man upon his visit to the *famille MacMonnies* in Giverny in 1901. *The French Chevalier* is, in fact, a genre painting featuring family members and friends of the artist, and both its emotional and visual focal point is Berthe MacMonnies, the fair-haired first child (figure 10). Born in the early fall of 1895, Betty, as she was known, appears in a number of paintings from just around the turn of the century by both Frederick and Mary. As Derrick R. Cartwright's essay for this catalogue makes clear, the child is central to the personal references in Mary MacMonnies' *Dans la nursery* and *C'est la fête à bébé*, both of which were painted at the very end of the century (see page 34 and 47). Although Marjorie, who was born in 1897, does appear with her mother in the background of *Monsieur Cardin*, it is the resplendent figure of Betty—particularly in *The French Chevalier*, but also in other works of the period—that captures our attention.

Berthe with Doll Amelia, 1898-99, which reveals a somewhat younger and chubby-cheeked Betty, features the beautiful child in an oversized chair clutching her favorite doll (figure 11). According to Betty's daughter, "Amelia" was the favored childhood doll, who due to excessive affection underwent periodic reincarnations in the able hands of Mary MacMonnies.[33] That the rag doll was a constant, or at least a very familiar, companion for the elder of the MacMonnies children is evident by its inclusion in the group portrait. Both depictions of Betty suggest that beautiful dresses and beribboned hair were deemed appropriate (probably by *Maman*) for having one's portrait painted. The same was apparently true for having one's photograph made, as several family photographs from the period reveal (figures 12 and 13). In these charming snapshots of family life on the Giverny property (probably taken by Frederick), both Betty and Marjorie are captured in their finest frilly dresses. Betty appears to be wearing a rather fancy "peau de soie" coat in *The French Chevalier*; her doll Amelia also seems to don a tiny pink coat perhaps made to imitate "mommy Betty's."[34] The child also wears her best ankle-strap shoes, which appear in at least one of the photographs and in an ambitious family portrait also painted that year, *Mrs. Frederick MacMonnies and Children in the Garden of Giverny*, now in the Musée des Beaux-Arts, Rouen (figure 14). In the latter canvas, one of the few works by MacMonnies for which a painted study is known, the female members of the family rest in the estate's *charmille*, or tree-lined walkway, in the company of the nursemaid, Lili, who is quietly engaged in her sewing (figure 15). This

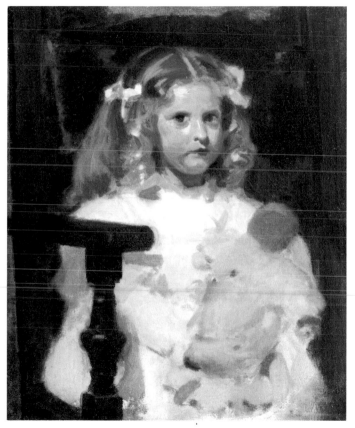

Figure 11 Frederick William MacMonnies, *Berthe with Doll Amelia*, 1898-99. Oil on canvas on masonite, 23 1/4 x 19 1/4 inches. The Schwarz Gallery, Philadelphia

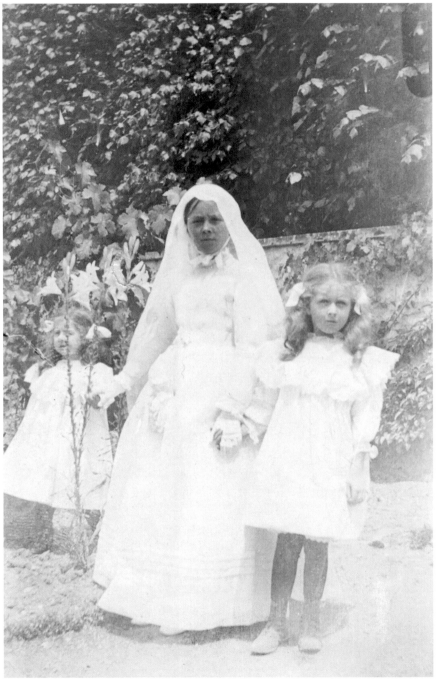

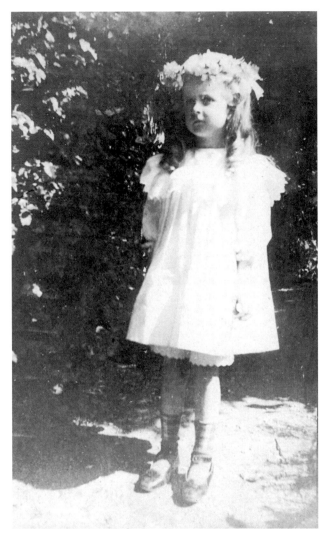

Figure 13 *Berthe Hélène MacMonnies*, 1901. MacMonnies family papers. Photograph courtesy of E. Adina Gordon

Figure 12 *Marjorie and Berthe MacMonnies with a governess*, c. 1901. MacMonnies family papers. Photograph courtesy of E. Adina Gordon

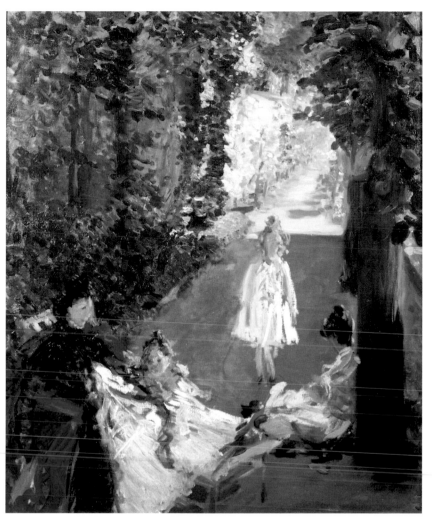

Figure 14 Frederick William MacMonnies, *Mrs. Frederick MacMonnies and Children in the Garden of Giverny*, 1901. Oil on canvas, 96 1/2 x 88 1/2 inches. Musée des Beaux-Arts, Rouen. Gift of Berthe MacMonnies Hazard, 1939. Photograph, Giraudon

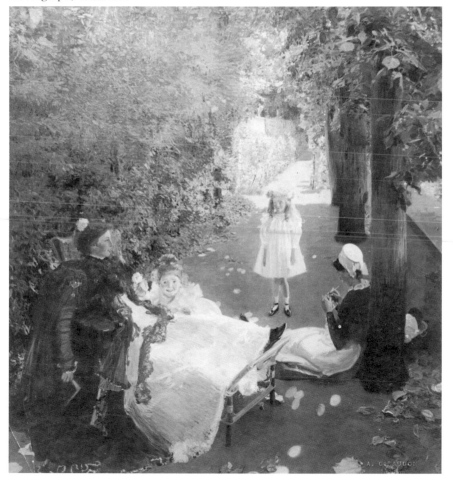

Figure 15 Frederick William MacMonnies, *Mrs. Frederick MacMonnies and Children in the Garden of Giverny* (study), 1901. Oil on canvas, 25 x 21 inches. Private collection

gathering of women in their most beautiful dresses in a most delightful setting suggests that despite a growing emotional distance between Frederick and Mary, moments of joy centered on the children punctuated the lives of the MacMonnieses in the summer and fall of 1901.[35]

The one figure missing from this idyllic gathering is, of course, the paterfamilias, though his presence as creator of the group portrait is obviously implied. In *The French Chevalier*, MacMonnies' masculine presence as both artist and patriarch of the family is visualized in the self-portrait reflected in the mirror at the upper left of the canvas (figure 16). It is this detail, this pointed inclusion of the artist at work, that further complicates an already complex painting. The work continues to resist easy categorization, for it is in essence a portrait of a gentleman posed in costume, a genre painting of the MacMonnies household, *and* a self-portrait of the artist at work. This incorporation of the portrayed artistic self within a domestic group setting, of course, has an important and well-known precedent, the *Las Meninas* by the great Spanish court painter, Diego Velázquez (figure 17). This "hall of mirrors," as another great Spaniard, Pablo Picasso, called it, is surely one of the most visually and intellectually complex paintings in the history of art.[36] Most nineteenth-century observers would have agreed with the placard at one time on display in the Prado, which identified the canvas as the "culminating work of world art."[37] For MacMonnies, who dictated his thoughts on the Spanish artist very likely at the time when *The French Chevalier* was in progress, *Las Meninas* was indeed "the highest achievement of true painting…an artistic triumph and an historic jewel."[38]

Although Velázquez was renowned for his skill as a painter in the court of Philip IV in his own day, it was not until the mid- to late 1800s that his apotheosis as a modern master was assured. The growing rage for all things Spanish throughout the century helped in this glorification of the artist, as did the century's insistent quest for stark realism and painterly bravura, the hallmarks of the Spaniard's style. Many American artists, including MacMonnies, added Spain to their grand tour itineraries in the final decades of the century and registered as copyists at the Prado in Madrid. For Thomas Eakins, Velázquez' work represented the quintessence of "unaffected nature," while Mary Cassatt was struck by its remarkable verisimilitude.[39] The respected teacher and well-known society portraitist William Merritt Chase, however, identified the artist as the "most modern" of the old masters because of his dashing manipulation of pigment on canvas. "No living painter," he opined, "could produce work more pleasing to the eye of the modern critic."[40] Most remarkable ultimately was Velázquez' seeming ability to accomplish both tasks; that is, the convincing mimesis of the visible world (particularly a sense of atmospheric space) achieved via an unabashed acknowledgment of the reality of paint.

For MacMonnies, Velázquez' nearly life-size masterwork was most remarkable for its "illusion of reality" and "naturalness of composition." The *Las Meninas*, he suggests in his manuscript, "is not an arrangement but an everyday occurrence."[41] This was the

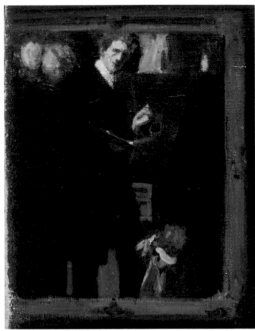

Figure 16 Frederick William MacMonnies
The French Chevalier, 1901 (detail)

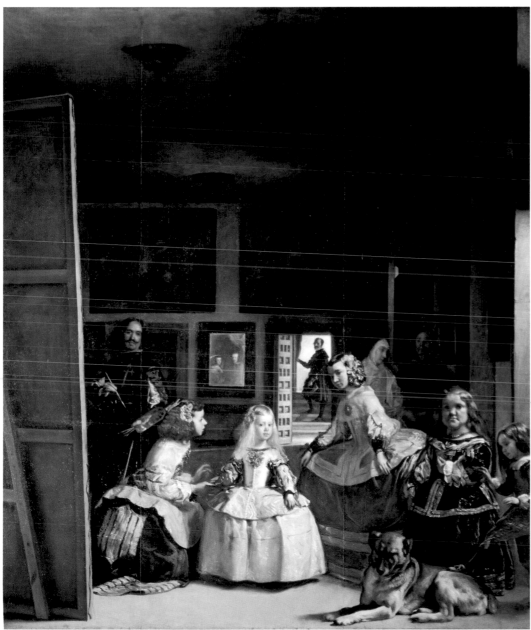

Figure 17 Diego Velázquez, *Las Meninas*, 1656. Oil on canvas, 126 3/8 x 110 5/8 inches. Museo del Prado, Madrid

commonly held perception of the picture in the nineteenth century, namely that it represented an extraordinary glimpse—a kind of snapshot, as it were—of everyday life in the royal palace of Philip IV. The painting takes its name, which was not given to it until 1843, from the handmaidens or maids of honor who attend the 5-year-old infanta, María Margarita. The *menina* on the left offers the child some water in a small vessel, while one of the two court dwarfs on the right playfully teases a large obliging dog. Behind this casually posed frieze of figures in the foreground stand two chaperons, one in a nun's habit, who converse quietly. In the distance, silhouetted against an open doorway, is the *Aposentador*, the queen's chamberlain, who has paused to look back at the group.

Dominating the canvas by his authorial presence is the figure of the artist himself, brush in hand, standing before an enormous canvas. His gaze is directed beyond the space of this palace room to a point in front of the canvas. The presence of King Philip and Queen Mariana is brilliantly visualized in the mirror reflection in the distance. The sovereign couple thus seems to occupy that liminal space in front of the painting normally reserved for the viewer. This grand palace room with its magnificent array of paintings clearly visible has temporarily been converted into the artist's studio. Velázquez has momentarily ceased work on his canvas to acknowledge the entrance of the monarch and his consort, and this "royal epiphany," according to Jonathan Brown, is the central event of the picture. The entrance of the king and queen clearly has caught the attention of those individuals who gaze outward, and the standing maiden has actually begun to curtsey in acknowledgment of the royal presence.

The work's remarkable verisimilitude results both from the transgression of the boundaries of the painting's fictive pictorial space and its uncanny sense of "arrested motion."[42] For MacMonnies, the *Las Meninas* was "the most extraordinary masterpiece of realism ever painted," and *The French Chevalier* is clearly an homage in part to that verism.[43] "The dwarfs and dog and waiting maids, the presence of the King and Queen in the foreground reflected in the mirror behind the painter," MacMonnies recounts, "shows that it might have happened so." It is precisely this sense of life interrupted that MacMonnies endeavors to recreate in his complex portrait *cum* genre painting. The figure of Mary MacMonnies, who appears to have just entered the room and leans over seemingly to engage the elder Thesmar in conversation, effectively conveys this sense of a captured moment. It is her entrance into this theatrical space that has momentarily interrupted the painting session. (The same is true in *Monsieur Cardin*). As does *Las Meninas*, the painting ultimately hinges on "the golden, radiant centrality of the child," to borrow David Lubin's mellifluous description of the infanta.[44] It is unclear whether Betty is herself posing alongside her godfather or whether she too has just entered the space in an effort to engage her father's attention. Notably, she alone looks directly at the viewer, who, as noted above, occupies the directorial position of the artist himself. In other words, it is Betty who gazes directly at her father and most fully engages his attention.

Figure 18 John Singer Sargent, *Infanta Margarita after Velázquez*, 1880. Oil on wood, 13 7/8 x 9 1/2 inches. Private collection

MacMonnies was clearly not alone in his fascination with Velázquez' convoluted masterpiece, nor in his co-opting of the painting's domestic/theatrical nexus for his portrait of family life in Giverny. John Singer Sargent's well-known group portrait of the daughters of Edward Darley Boit, which was exhibited at the Salon of 1883 one year prior to MacMonnies' arrival in Paris, is a remarkable variation on the theme (figure 19). Sargent had visited the Prado in 1879 and copied at least thirteen works by Velázquez, including *Las Meninas* (figure 18). The 1879 trip to Spain, the first of several for Sargent, came at the end of his formal training in Paris under the tutelage of Carolus-Duran (Charles-Emile-Auguste Durand).[45] As a student in this popular atelier, the cosmopolitan young artist undoubtedly heard and dutifully heeded his French master's sage recommendation to "ceaselessly study Velasquez." Sargent's indebtedness to the Spanish artist includes most obviously his brilliant loaded brushwork, but also the uncanny sense of atmos-

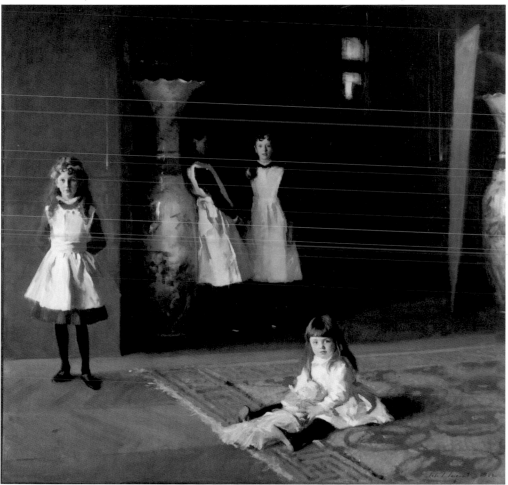

Figure 19 John Singer Sargent, *The Daughters of Edward Darley Boit*, 1882. Oil on canvas, 87 3/8 x 87 5/8 inches. Museum of Fine Arts, Boston. Gift of Mary Louisa Boit, Julia Overing Boit, Jane Hubbard Boit, and Florence D. Boit in memory of their father, Edward Darley Boit, 19.124

pheric space enveloping his figures. In *The Daughters of Edward Darley Boit*, the four "infantas" of a wealthy expatriate pose in the family's palatial apartment in Paris. The placement of the two older girls deep in the darkened cavernous space, the focusing of the pictorial interest on the beautifully dressed youngest child, and the placement of a backlit window in the distance all call to mind Velázquez' spacious group portrait. Critics at the time were quick to make the connection between *The Daughters of Edward Darley Boit* and *Las Meninas*. According to Henry James, no less, who greatly admired Sargent's unorthodox portrait, Velázquez was the "god" of Sargent's "idolatry."[46]

Other American portraitists drew on *Las Meninas* for inspiration, particularly in painted homages to their own artistic enterprise. George Bellows' *The Studio*, 1919, though several decades later than the Sargent, similarly evokes its great Spanish predecessor (figure 20). Although Bellows is best known today for his gritty realist depictions of boxing scenes and urban life, portraiture was central to his ambition to be a great artist, as it was for MacMonnies. That portraiture played an important role in the artist's sense of self is apparent in *The Studio*, which was initially conceived as a lithographed Christmas card in 1916.[47] The painting is set in Bellows' spacious home studio in New York City, and the artist, brush in hand, can be seen at left contemplating his wife as he begins his portrait of her. This detail of Bellows at work is clearly set within the artist's (decorated) domestic habitat. The mother-in-law, who talks on the telephone, appears in the middle distance alongside a black servant; the children—two brightly garbed young girls—are absorbed in play in the foreground; and above the scene, like some *deus ex machina* stagehand, is Bellows' printer, George Miller, whose presence confirms the working component of this homely environment. In its depiction of the artist before his easel, its focusing of attention visually and compositionally on the beautiful *petites filles*, and its attention to the vast art-filled interior, the painting frankly pays tribute to Velázquez' masterpiece. As H. Barbara Weinberg has argued, "Bellows literally painted in the midst of his own life—depicting his family engaged in ordinary activities—and fulfilled his stated credo that 'all living art is of its own time.'"[48]

William Merritt Chase, an artist closer in time and spirit to MacMonnies, demonstrates virtually the same creed in *Hall at Shinnecock*, 1892, his homage to the seventeenth-century portrait (figure 21). Completed late in his career at a time when the artist was summering regularly at Shinnecock Hills on the eastern end of Long Island, this charming interior reveals the artist's wife and two of his children happily going about the leisurely routine of their privileged lives. More importantly, the reflection of Chase standing before an easel in the armoire's mirrored doors transforms the beautifully decorated familial room into a *de facto* studio space. The 1890s witnessed the gradual decline of Chase's national preeminence as an artist and teacher, and as a result, the artist's work leading up to the turn of the century draws substantially on his personal domestic situation and reveals a new inwardness and a questioning of his own art making.[49] Although Chase had visited Madrid specifically to study the work of Velázquez a little over a

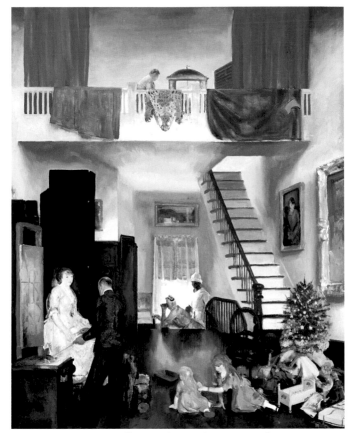

Figure 20 George Bellows, *The Studio*, 1919. Oil on canvas, 48 x 38 inches. Collection of Rita Fraad. Photograph courtesy of Gerald Peters Gallery, Sante Fe

Figure 21 (opposite) William Merritt Chase, *Hall at Shinnecock*, 1892. Pastel on canvas, 32 1/8 x 41 inches. Terra Foundation for the Arts, Daniel J. Terra Collection, 1988.26. Photograph courtesy of Terra Foundation for the Arts, Chicago

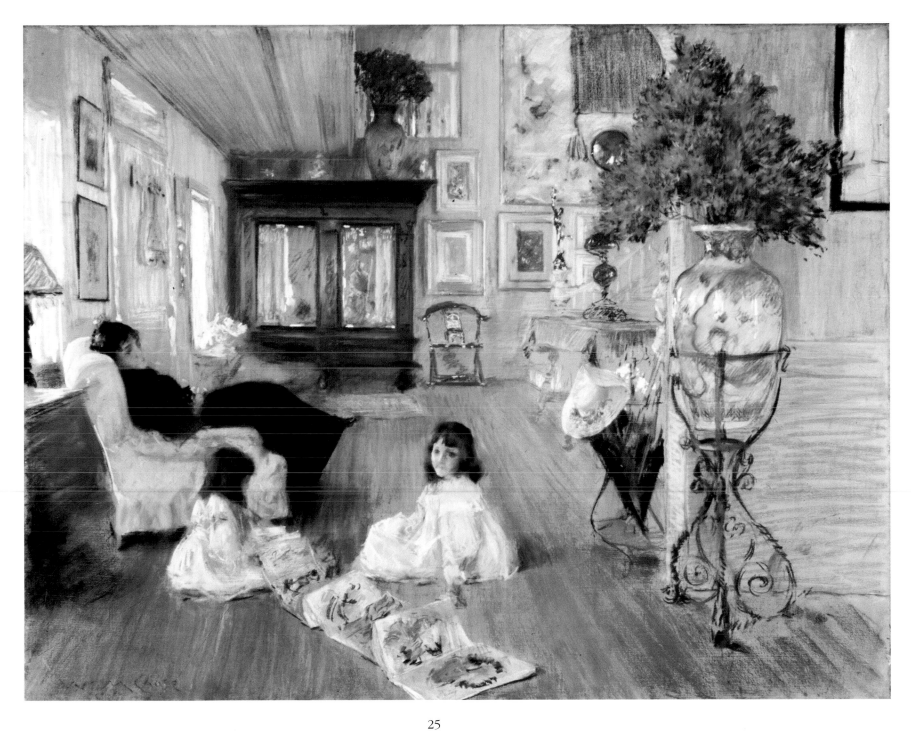

decade before painting *Hall at Shinnecock*, the Spanish master reigns supreme in many of the late interiors. Indeed, in the last decade of his life, Chase continued to emulate the "supreme example" of Velázquez to the point of tacking a reproduction of what was believed to be a self-portrait of the artist and a detail from *Las Meninas* on his studio walls.[50] Chase even went so far as to name one of his daughters Helen Velasquez, whom he depicted at approximately age 5 or 6 in a magnificent "princess" gown in *My Little Daughter Helen as an Infanta*, 1899 (Santa Barbara Museum of Art).

The pose assumed by Chase in his reflected self-portrait in the Shinnecock interior is remarkably close to that assumed by MacMonnies in *The French Chevalier*; both find their source in the painting by Velázquez. Chase and MacMonnies were not alone in this pictorial and ideological coalescence of their identities as artists with the shining example of the Baroque painter. The international audience who passed through the impressive installation of American art at the 1900 Universal Exposition in Paris might have recognized a similar bolstering of artistic reputation through the imprimatur of tradition in Whistler's *Brown and Gold*, a full-length self-portrait based on Velázquez' *Pablo de Valladolid* in the Prado (figure 4). Diane Fischer has recently argued that by exhibiting his recognizable self-portrait in the American section of the exposition—he had shown with the British at the 1889 fair—Whistler "became a part of the national school's iconography—the American artist as old master."[51]

Nearly a half century earlier, Whistler had had his first extensive encounter with the Spanish court painter's work in an exhibition in Manchester. Although he never made it to Madrid, among Whistler's studio effects at the time of his death were nine photographs of works by Velázquez, including the *Pablo de Valladolid* and, tellingly, a detail from the left side of *Las Meninas* showing three of the foreground figures: the artist, and attendant, and the infanta.[52] Whistler indeed had paid homage to Velázquez' great portrait in *The Artist's Studio*, 1865, an early sketch depicting the artist at work in his studio, palette and brush in hand (figure 22). The project was never realized, and the sketch was intended merely as a preliminary exploration in preparation for a more ambitious figural composition.[53] In the sketch, Whistler gazes directly out at the viewer *à la Velázquez* in the company of two female models. Jo, his mistress, is seated on a settee in front of the artist's impressive porcelain collection accentuating the familiar confines of this domestic milieu. The other model—whom Whistler referred to as "La Japonaise"—reveals not only the artist's indebtedness to the decorative stylizations of Japanese art, but also the highly artificial nature of his ostensibly realist enterprise. Clearly in costume and holding a Japanese fan (Whistler wears Japanese patens on his feet), the model is the exotic adornment in this otherwise mundane setting.

This notion of costumed artifice within the artist's studio leads us back, of course, to *The French Chevalier*; however, we might first note its use in the work of Bellows and Chase, both of whom obviously shared MacMonnies' interest in Velázquez and the *Las*

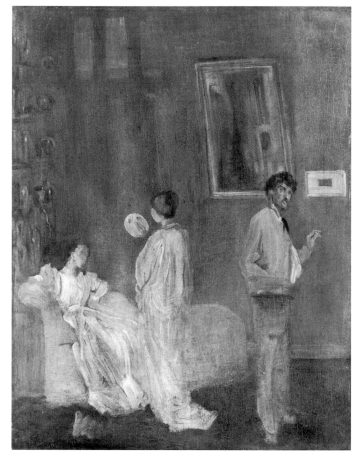

Figure 22 James McNeill Whistler, *The Artist's Studio*, 1865. Oil on cardboard, 24 1/2 x 18 1/4 inches. Hugh Lane Municipal Gallery of Modern Art, Dublin

Meninas. In Bellows' *The Studio*, the artist's wife, Emma, who is posing for her portrait, is dressed not in the up-to-the-minute fashion that we might expect from this realist venture, but in a decidedly feminine gown from another era. Chase similarly encouraged his models to don old-fashioned garb in the otherwise up-to-date paintings of his famous Tenth Street studio (figure 23). In one of the most familiar of these, *In the Studio*, c. 1880, we find a young woman wearing a dress and bonnet from the early nineteenth century, underscoring, it has been noted, "the role of artifice in the creative process."[54]

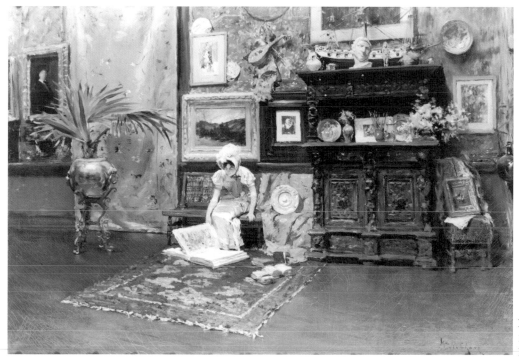

Figure 23 William Merritt Chase, *In the Studio*, c. 1880. Oil on canvas, 28 1/8 x 40 1/16 inches. Brooklyn Museum of Art. Gift of Mrs. Carll H. DeSilver in memory of her husband, 13.50

Although MacMonnies' studio picture lacks the self-referential clutter of the Chase painting, his portrait of his friend Georges Thesmar dressed as a French *cuirassier* reveals a similar strategy in its careful siting of the feigned within the real. When *The French Chevalier* was first introduced to the public in 1903 at the Durand-Ruel show, critics, many of whom highly praised the effort, read this costumed figure in at least two different ways. Writing for *The Century Magazine*, Pauline King seemingly was duped by the machination: "How accentuated is the simple character, the unconscious attitude of a very strong, brave young man! Nothing could be less posed. He is painted just as he stood up in the studio, as straight as though on guard, a stalwart figure, with a plain, unaffected face."[55] MacMonnies might well have been delighted with this "realist" interpretation—the "slice of life" version—of his monumental group portrait. Other critics

saw things a bit differently, including one reporter who brought up the painting just after a fairly extensive discussion of the *plein-air* realism of *Mrs. Frederick MacMonnies and Children in the Garden of Giverny* (figure 14). "In contrast to this painting is another large canvas representing M. Georges Thesmar, who is in the uniform of a cuirassier, and with moustaches [*sic*] almost kaiserlische, is trying to look warlike, despite the fact that a pretty little girl is pulling at his cloak, while her mother and an old gentleman in the background are smiling at the tableau."[56] For this critic, the artifice of the "tableau" was easily penetrated.

That Georges Thesmar is indeed posing as a *cuirassier* is strongly suggested by another of MacMonnies' large canvases from early on in his painting sabbatical, *Portrait of a Boy on a Toy Sheep*, 1898 (figure 24). In this work, a young boy, the half-brother of Ellen Emmet, one of the artist's students, is "playing soldier" in front of one of several tapestries in the MacMonnies household. Sword and pistol in hand, he wears a diminutive *cuirass* (its gleam rendered in a palette remarkably close to *The French Chevalier*), epaulets, and the guard's distinctive plumed helmet. The fiction of the child as *cuirassier* is extended via the toy sheep, which furthers the linkage of this "soldier" with the elite cavalry guard. The tapestry also identifies this space as a realm given over to art and the creative fabrication of illusions; we know that the artist kept several tapestries in his painting studio in Giverny.[57] The use of this artful backdrop is not unlike the inclusion of a framed painting and a mirror in the background of *The French Chevalier*, both of which call attention to the essentially fictive nature of the artist's enterprise. The presence of a mirror within the studio picture—we find it also in Chase's *Hall at Shinnecock* and most prominently in the Velázquez—forces us to consider the nature of representation and question the relationship between reality and its fictive simulacrum. Painting, regardless of its realist intent, is ultimately an illusion, and both the mirror and the costumed *cuirassier* remind us of that fact. Velázquez well understood this, as did his twentieth-century countryman Pablo Picasso, whose many variations on *Las Meninas* from late in his career similarly assert the fictive construct of painting and reify the primacy of the artist as conjurer of the artwork's "reality" (figure 25). Once considered "truth and not painting," as Susan Galassi has noted, the *Las Meninas* has come to represent "painting and not truth."[58]

For MacMonnies as for Picasso, the decision to take on Velázquez resulted from a desire to pay homage to the great master of the past, to ruminate on his considerable achievement, and to insinuate themselves into the "history" of this most famous painting. The artist's identification with Velázquez was no passing fancy. In 1904 he again made the pilgrimage to Madrid and returned with several copies, many of which are now unlocated, after Velázquez originals. From letters to his student Mary Foote, we know that MacMonnies continued his fascination with the Spaniard's brilliant painterly style to the point of surmising and outlining step by step the artist's process. At the time of the 1903 Durand-Ruel exhibition, critics had already noted (many derisively) the emphatic bold-

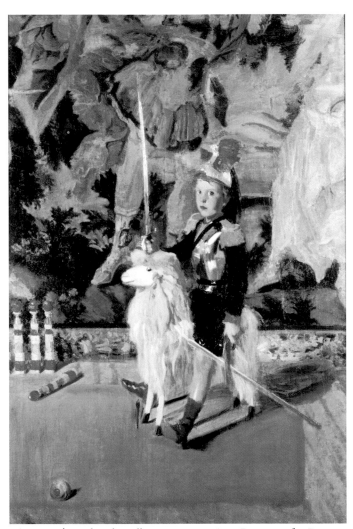

Figure 24 Frederick William MacMonnies, *Portrait of a Boy on a Toy Sheep*, 1898. Oil on canvas, 75 1/4 x 50 1/2 inches. Collection of Donald and Lisa Purdy. Photograph courtesy of E. Adina Gordon

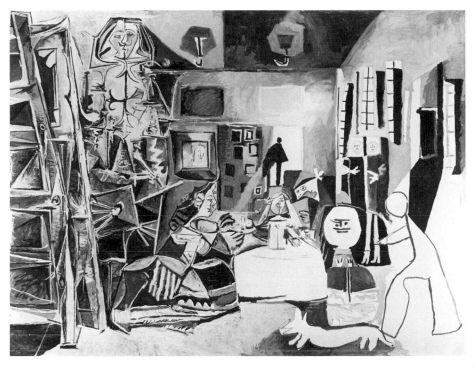

Figure 26 Frederick William MacMonnies, *The French Chevalier*, 1901 (detail)

Figure 27 Frederick William MacMonnies, *The French Chevalier*, 1901 (detail)

ness of MacMonnies' technique. Writing for the *New York Evening Post*, one observer noted that "as the color is usually put on almost pure, and very broadly, the first impression is one of extreme crudity and vulgarity." However, the critic continued, "if one has the courage to tarry a while, he becomes to a degree accustomed to the coarseness on every side, and begins to see much to admire in the way of draughtsmanship, sense of light, and originality of conception."

In *The French Chevalier* MacMonnies demonstrates a wide range of representational tactics in emulation of the varied techniques in *Las Meninas*. In both works the "infantas" are the most carefully rendered characters; the features of the middleground figures are much less distinct (figure 26); and the mirror reflections are virtually sketchlike. For MacMonnies this selective painterly focusing contributed to the Spaniard's striking ability to portray his sitters "bathed in light and air." "True painting," MacMonnies averred, "should be the representation of natural objects, by means of color glowing and deepening around and above the form it has brought into existance [*sic*], presenting the impression of truth to the eye. Velasquez stands as the type of painter who with oil paints and brushes has truly painted the illusion of nature as she is."[59] Despite this remarkable optical verism, the reality of paint on canvas is ever present in both the Velázquez and the MacMonnies paintings, particularly in the detail of the soldier's glim-

mering *cuirass* (figure 27). In gazing upon this astonishingly abstract passage we might be led to agree with Samuel Isham, an early historian of American art, who in 1905 applauded MacMonnies' technique for its amazing "boldness and breadth."[60] Visual evidence of the painting's support, a rough-toothed, burlap-like canvas, is also present in this painterly detail, further corroborating the artist's frank acceptance of the physical exigencies of his illusionistic craft. Many years after completing *The French Chevalier*, MacMonnies was asked his opinion on the extreme abstraction in recent work of the European avant-garde. "I think their revelation yields something," he responded. "It leaves an aroma or some appreciation of the thing on the surface."[61]

Despite this statement, MacMonnies was a child of the nineteenth century whose art throughout his career remained rooted in naturalism and whose acknowledged guiding light was a seventeenth-century Baroque master of illusionistic painting. ("Velasquez never painted a button without a model, and don't you," he advised his daughter.[62]) Although he might have understood the impetus behind them, MacMonnies would probably have been perplexed by the "pictorial cannabilism" of Picasso's *Las Meninas* variations.[63] Yet, like Picasso, he too hoped to measure his own accomplishments against one of the great paintings in the history of art and, indeed, to place himself in that history. His identification with Velázquez remained a constant throughout his painting furlough, and as many of the self-portraits from this period reveal, MacMonnies' construction of his self-identity as a modern painter was inextricably bound to his profound emulation of the old master. In the *Self-Portrait*, c. 1904, in the collection of The Metropolitan Museum of Art, we find the artist posed before a reflected image of a copy (likely his own) after Velázquez' *Feast of Bacchus* from the Prado (figure 28). Dapperly dressed, palette and brush in hand, the artist plays the part of the successful and accomplished painter in this representation of his professional persona.

Equally revealing, perhaps, is the now lost *Self-Portrait "as Velasquez Made Me See Myself,"* c. 1904, in which the artist appears in sportive costume, with a fencing foil replacing the ubiquitous brush (figure 29). MacMonnies cuts a dashing, even "princely" figure in this self-representation in which foil easily reads as sword and artist as aristocrat. Like any person well versed in the mystique of Velázquez in the nineteenth century, MacMonnies would have been aware of the court painter's desire to elevate his personal and professional status via induction into the Order of Santiago, one of Spain's most elite aristocratic military orders. Velázquez was made a Knight of Santiago in 1659, a year before his death and three years after completion of the *Las Meninas*, and part of the lore accompanying the picture was that the king himself painted the order's emblematic red cross visible on the breast of the artist. Jonathan Brown has argued that the presence of the sovereign in the picture (even if only as a ghostly reflection) is critical to unraveling the true meaning of the painting. Philip IV and his court painter enjoyed an unusual friendship, and the trope of the "studio visitation" is devised by Velázquez to suggest the ennobling of both his art and his person via the royal presence.[64] Neither a

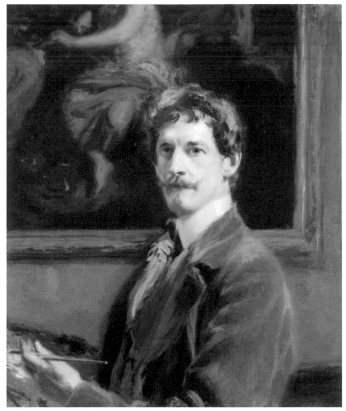

Figure 28 Frederick William MacMonnies, *Self-Portrait,* c. 1904. Oil on canvas, 31 x 25 inches. The Metropolitan Museum of Art. Gift of Mrs. James W. Fosburgh, 1967

simple craftsman nor a slavish copier of nature, the artist ultimately in *Las Meninas* celebrates his powers as the intellectual arbiter and master of his aesthetic domain.

The French Chevalier is clearly not as complex a picture as its Spanish predecessor, though we might argue that MacMonnies too presents himself as a kind of master of both his personal and professional domains. This almost rarefied image of the artist as painter suggests nothing of the backbreaking grind of the sculptor's life and indeed very little of the physical evidence—the standard studio accoutrements—of his craft. A contemporary photo of MacMonnies at work before an easel reveals somewhat more about his trade but similarly focuses on the cravated gentleman contemplating his creation (figure 1). Quite noticeable over the artist's left shoulder is a reproduction of a Velázquez, probably an infanta portrait, a regal reminder of both his aesthetic allegiances and, perhaps, the inherent nobility of his calling. "If I have any talent at all," MacMonnies noted toward the end of his life, "it is for painting," and it is as a painter that he asks us to remember him in *The French Chevalier*, his most ambitious self-portrait. Surely it is telling that the artist never referenced his considerable success (or hard work) as a sculptor in any of his self-portraits.[65] MacMonnies was much lauded and indeed highly decorated for his achievements in sculpture. In 1896 he was admitted into the French Legion of Honor at the rank of *chevalier*, the lowest of the Legion's five classes of knights, yet nonetheless a prestigious honor that obviously resulted from his three dimensional work.[66] Perhaps in *The French Chevalier* MacMonnies hoped to demonstrate his prowess as a "prince of painters," a true *chevalier*, if you will, and the painting's appearance at the Salon in 1906 helped to publicize the fact. Ironically, it was shortly after this time that MacMonnies put the brush aside and once again turned almost exclusively to sculpture.

The French Chevalier remained in the family well into the twentieth century where it functioned no doubt as a vivid reminder of the artist's brief public career as a painter and as a bittersweet memento of a seemingly united MacMonnies household. The painting reveals nothing of the emotional distance (already present in 1901) that would ultimately lead to the dissolution of the MacMonnies marriage a few years later. Despite MacMonnies' ostensibly realist goals, *The French Chevalier* is of course a fictive construct on every level, from its costumed leading character and its surface-affirming brushwork to its portrayal of domestic unity and familial bonds. Perhaps the diminutive Betty, probably the work's most visually and emotionally compelling figure, can function for us a bit like the reproduction of the *Infanta Margarita* in MacMonnies' painting studio, a resplendent reminder of her father's noble venture as a painter and of a brief, but happy interlude in Giverny.

Figure 29 Frederick William MacMonnies, *Self-Portrait "as Velasquez Made Me See Myself,"* c. 1904. Oil on canvas, 32 x 20 inches. Location unknown. Photograph courtesy of E. Adina Gordon

Notes

1 McKim, Mead & White\Frederick MacMonnies Correspondence. MacMonnies family papers, photocopies, E. Adina Gordon.

2 "MacMonnies Will Return to New York," *New York Herald,* October 15, 1900.

3 Pauline King, "Open Letters: A Painting by Frederick MacMonnies," *The Century Magazine* 66 (August 1903): 637.

4 McKim, Mead correspondence, November 22, 1898.

5 Mary Smart, *A Flight with Fame: The Life and Art of Frederick MacMonnies,* with a Catalogue Raisonné of Sculpture and a Checklist of Paintings, by E. Adina Gordon (Madison, Conn.: Sound View Press, 1996). The paintings checklist compiled by Gordon has been an invaluable source of information for this project. The essential facts of MacMonnies' career, including his foray into painting, are also detailed in Ethelyn Adina Gordon, with *Avant Propos* and catalogue notes by Sophie Fourny-Dargère, *Frederick William MacMonnies et Mary Fairchild MacMonnies: deux artistes américains à Giverny,* exh. cat. (Vernon: Musée Municipal A.-G. Poulain, 1988). An additional useful source outlining MacMonnies' career is Robert Judson Clark, "Frederick MacMonnies and the Princeton Battle Monument," *Record of The Art Museum,* Princeton University, 43 (1984): 7-59.

6 David Lubin, *Act of Portrayal: Eakins, Sargent, James* (New Haven and London: Yale University Press, 1985), 3.

7 DeWitt McClellan Lockman, "Interviews with Frederick MacMonnies, N.A." *DeWitt Lockman Collection of Interviews with American Artists in the New-York Historical Society,* Archives of American Art, Smithsonian Institution, Washington, D.C., microfilm reel 503, February 15, 1927, 12. The first interview [I] took place on January 29, 1927; the first sheet of the second interview [II] dates the meeting as February 16, though all subsequent pages list the date as February 15. Lockman was a portrait painter and at one time president of the National Academy of Design. For a brief synopsis of the interview with MacMonnies, see Edward J.

Foote, "An Interview with Frederick MacMonnies, American Sculptor of the Beaux-Arts Era," *The New York Historical Society Quarterly* 61 (July/October 1977): 103-23.

8 Lockman, II, 12.

9 For further discussion of this and other sculptural works by MacMonnies mentioned in this essay, see E. Adina Gordon, "The Sculpture of Frederick William MacMonnies: A Catalogue Raisonné," in Smart, *Flight with Fame*; and Ethelyn Adina Gordon, "The Sculpture of Frederick William MacMonnies: A Critical Catalogue," Ph.D. diss., Institute of Fine Arts, New York University, 1998.

10 Lockman, I, 29.

11 Lockman, II, 11.

12 Lockman, I, 7. Gordon has rightfully reminded me that the Lockman interviews occurred more than twenty-five years after MacMonnies' "switch" to painting and cautions that the remembrances are occasionally exaggerated. Clearly, though, the artist recalled his renewed interest in painting as a profound move away from the cumbersome demands of sculpture.

13 As quoted in Sara Dodge Kimbrough, *Drawn from Life* (Jackson: University Press of Mississippi, 1976), 103.

14 As quoted in Kimbrough, 65.

15 See Sarah Burns, "Old Maverick to Old Master: Whistler in the Public Eye in Turn-of-the-Century America," *The American Art Journal* 22 (Spring 1990): 29-49.

16 See E. R. and J. Pennell, *The Life of James McNeill Whistler,* vol. II (Philadelphia: J.B. Lippincott Company, 1909), 228-46.

17 Gordon, *Frederick William MacMonnies et Mary Fairchild MacMonnies,* 53.

18 For a comprehensive overview of the appeal of the French countryside for American painters, see William H. Gerdts,

Lasting Impressions: American Painters in France, 1865-1915, exh. cat. (Giverny: Musée Américain Giverny, 1992).

19 Will H. Low, *A Painter's Progress* (New York: Charles Scribner's Sons, 1910), 447.

20 Will H. Low, "In an Old French Garden," *Scribner's Magazine* 32 (July 1902): 4.

21 MacMonnies to White, McKim, Mead correspondence, October 17, 1901. Low's account of the summer confirms this productivity. MacMonnies, Low writes, "had literally metres on metres of canvas, each large stretcher having a definite purpose which the summer saw fulfilled." Low, "In an Old French Garden," 13.

22 Lockman, II, 13. The studio inventory can be found in the MacMonnies family papers; photocopy provided by E. Adina Gordon.

23 Edith Pettit, "Frederick MacMonnies, Portrait Painter," *International Studio* 29 (October 1906): 319.

24 "Paintings by Mr. MacMonnies, Mr. Walker and Others," *New York Tribune,* January 21, 1903.

25 King, 637.

26 Frederick MacMonnies, "The Beautiful Arts of Painting and Sculpture," Mary Foote Papers, Beinecke Rare Book and Manuscript Library, Yale University.

27 MacMonnies, "Beautiful Arts," 12.

28 Low, "In an Old French Garden," 13. Low notes that during their visit "the aesthetic consideration of Realism *vs.* Memory, Imagination, or, to boldly accept the opponent's term, Chic, was often discussed...."

29 MacMonnies, "Beautiful Arts," 11+ and 11 [no. 3]. Between pages 11 and 12 in the manuscript, Foote inserted MacMonnies' several-page digression on the *Las Meninas.* The pages are thus numbered 11, 11+, 11 [no. 3], 11 [no. 4], and 11 [no. 5].

[30] Lockman, II, 13.

[31] For a recent article on the enamelist, see Régine de Plinval de Guillebon, "Art Nouveau: Les Emaux de Fernand Thesmar," *Estampille, l'objet d'art*, no. 276 (Janvier 1994): 44-53. For a more detailed discussion of the *Cupid*, see Gordon, "The Sculpture of Frederick MacMonnies: A Critical Catalogue," cat. no. 53.

[32] "Stories of Paintings, by Frederick MacMonnies, from his Giverny Studio; as related to his granddaughter Marjorie M. Young, by his daughter, Berthe Hélène MacMonnies." Photocopy, E. Adina Gordon.

[33] According to Marjorie M. Young, "My mother liked to tell how Amelia was a sort of 'perennial' ragdoll made for her by her mother, Mary Fairchild MacMonnies (Low); in that she received a new face, or arms or legs (made from stockings); whenever these became worn or soiled; but of course, the original design was always faithfully followed; so that Amelia emerged from each rejuvenation, looking exactly as she always had." Note on the back of *Berthe with Doll Amelia*, Schwarz Gallery, Philadelphia.

[34] This description of the pink coat apparently derives from Betty. See "Stories of Paintings," n.p.

[35] See Derrick R. Cartwright's essay for a more in-depth discussion of the problems in the MacMonnies marriage.

[36] As quoted in Marie-Laure Bernadac, "Picasso 1953-1972: Painting as Model," in *Late Picasso*, exh. cat. (London: The Tate Gallery, 1988), 61.

[37] Leo Steinberg, "Velázquez' *Las Meninas*," *October* 19 (1981): 45.

[38] MacMonnies, "Beautiful Arts," 11, 11 [no. 5].

[39] Carol M. Osborne, "Yankee Painters at the Prado," in *Spain, Espagne, Spanien: Foreign Artists Discover Spain, 1800-1900*, exh. cat. (New York: The Spanish Institute, 1993), 59.

[40] William M. Chase, "Velasquez," *Quartier Latin* 1 (July 1896): 4.

[41] MacMonnies, "Beautiful Arts," 11 [no. 4].

[42] Jonathan Brown, *Images and Ideas in Seventeenth-Century Spanish Painting* (Princeton, N.J.: Princeton University Press, 1978), 90.

[43] MacMonnies, "Beautiful Arts," 11 [no. 4].

[44] Lubin, 102.

[45] M. Elizabeth Boone, "Vistas de España: American Views of Art and Life in Spain, 1860-1898," Ph.D. diss., The City University of New York, 1996, 188.

[46] Henry James, "John S. Sargent," *Harper's New Monthly Magazine* 75 (October 1887): 686, as quoted in Marc Simpson, Richard Ormond, and H. Barbara Weinberg, *Uncanny Spectacle: The Public Career of the Young John Singer Sargent*, exh. cat. (Williamstown, Mass.: Sterling and Francine Clark Art Institute, 1997), 57.

[47] Jane Myers, "'The Most Searching Place in the World': Bellows and Portraiture," in Michael Quick, et al., *The Paintings of George Bellows*, exh. cat. (Fort Worth, Tex.: Amon Carter Museum, 1992), 171.

[48] H. Barbara Weinberg, *American Realism and Impressionism: The Painting of Modern Life, 1885-1915*, exh. cat. (New York: The Metropolitan Museum of Art, 1994), 43, 46. On the relationship between the Bellows and the Velázquez painting see also Eleanor Tufts, "Realism Revisited: Goya's Impact on George Bellows and Other American Responses to the Spanish Presence in Art," *Arts Magazine* 57 (February 1983): 105-13.

[49] For an extensive discussion of Velázquez' influence on the late work of Chase see Nicolai Cikovsky, Jr., "Interiors and Interiority," in D. Scott Atkinson and Nicolai Cikovsky, Jr., *William Merritt Chase: Summers at Shinnecock, 1891-1902*, exh. cat. (Washington, D.C.: National Gallery of Art, 1987).

[50] As quoted in Walter Pach, "The Impact of Art," *The Outlook* 95 (June 25, 1910): 442.

[51] Diane P. Fischer, ed., *Paris 1900: The "American School" at the Universal Exposition*, exh. cat. (Montclair, N.J.: The Montclair Art Museum, 1999), 22.

[52] See Nigel Thorp, "Studies in Black and White: Whistler's Photographs in Glasgow University Library," *Studies in the History of Art* 19 (1987): 85-100.

[53] For a recent discussion of this project see Eric Denker, *In Pursuit of the Butterfly: Portraits of James McNeill Whistler*, exh. cat. (Washington, D.C.: National Portrait Gallery, Smithsonian Institution, 1995), 55-58.

[54] Weinberg, *American Realism and Impressionism*, 46. For an extensive discussion of both the Bellows and the Chase paintings, see Weinberg, 42-49.

[55] King, 638.

[56] Clipping in MacMonnies family papers; photocopy, E. Adina Gordon.

[57] Pettit, 319.

[58] Susan Grace Galassi, "Picasso in the Studio of Velázquez," in Jonathan Brown, ed., *Picasso and the Spanish Tradition* (New Haven and London: Yale University Press, 1996), 121. The typical nineteenth-century response to the painting as "one of the most perfect fac-similes of nature that art has ever produced" is stated in Charles Boyd Curtis, *Velazquez and Murillo; a descriptive and historical catalogue of the works...* (New York: J.W. Bouton, 1883), 14.

[59] MacMonnies, "Beautiful Arts," 11 [no. 4], 11.

[60] Samuel Isham, *The History of American Painting* (New York: The MacMillan Company, 1936 [first edition, 1905]), 404.

[61] Lockman I, 7.

[62] Kimbrough, 151.

[63] Bernadac, 54.

[64] See Brown, 93-94.

[65] Lockman, II, 11.

[66] Smart, *Flight with Fame*, 159. MacMonnies was elevated to the rank of *commandeur* in 1933.

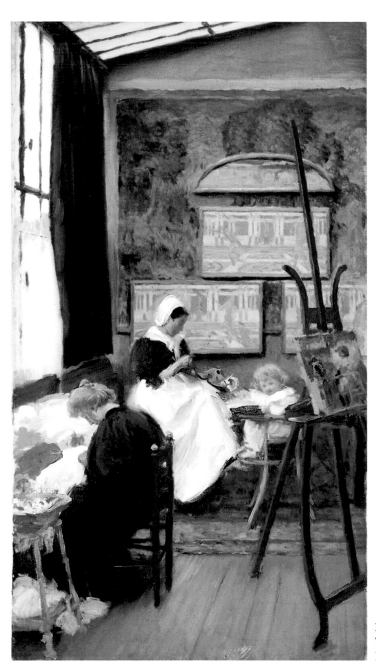

Figure 1 Mary Fairchild MacMonnies, *Dans la nursery*, c. 1896-98. Oil on canvas, 32 x 17 inches. Terra Foundation for the Arts, Daniel J. Terra Collection, 1999.91. Photograph courtesy of Terra Foundation for the Arts, Chicago

Beyond the Nursery:
The Public Careers and Private Spheres of Mary Fairchild MacMonnies Low

DERRICK R. CARTWRIGHT

At first glance, the vertical composition reveals an interior filled with decorous things (figure 1). We count five paintings, a large wooden *chevalet*, several pieces of ornate household furniture—chairs, baskets, tables overflowing with fabrics—as well as elaborate floor and wall coverings that serve to define the depth and width of this carefully plotted perspectival space. All of these objects are illuminated from a skylight above and a window at the left. In addition to these colorful furnishings, the room is further animated by three seated figures, each of them quietly attentive to her own activity. Two women anchor the lower left corner of the image. These adults are posed intently, absorbed by the handwork in front of them. A young child in a high chair occupies the center of the canvas. Unlike the others who are turned away from the spectator, this little girl in fancy white collar and yellow dress stretches out from behind the easel in the right middle-ground of the picture and stares directly at the viewer. The slightest indication of a smile enlivens her cherubic face and her right arm is extended, as if caught in the act of waving, or wielding an imaginary paintbrush. Within this hybrid setting—part nursery, part atelier—such plentiful detail resonates with profound visual and imaginative force. This is no simple picture.

Dans la nursery is a luminous and complex autobiographical painting by Mary MacMonnies. Physically small, it can nonetheless be taken as an effort to catalogue the artist's surrounding environment at the moment of its creation. The description above begins to suggest this much, at least. Painted sometime between 1896 and 1898, the work almost certainly records the material circumstances of the artist's relatively recent, yet already quite everyday routine in Giverny, France.[1] More than this, the painting might also be said to represent her effort to comprehend the choices available to her at this precise juncture in her career. A gifted painter from a privileged background, then in charge of an active and growing household (she was likely pregnant with her second

child at the time this work was accomplished), MacMonnies was evaluating this environment with new purpose.[2] The image thus contrives to interpret what was, in fact, an especially critical moment for the artist, both professionally and personally. This is just to say that this singular picture, with its splendid array of people and things, its evocation of past and present artistic concerns—even the distance it implies between the position of the viewer and the space of representation—holds significance for our understanding of the artist. The present essay attempts to relocate *Dans la nursery* within this dynamic painter's life, and, in so doing, it mounts an argument for the appreciation of her work within a broader network of competing artistic practices at the end of the nineteenth century.

Mary Louise Fairchild was born in New Haven, Connecticut, on August 11, 1858 (figure 2).[3] She was the first of three children in the Fairchild family. Her father worked as an executive in the local telegraph office, and her mother was an artist who received some attention for her watercolors and miniatures. During the Civil War years, Sidney Fairchild moved his family from its longtime base in New England to New Orleans where he served as a military communications expert. Shortly after the war, the family relocated once again to St. Louis, where Mary completed high school and later received professional training as an educator. She spent several years teaching elementary school before enrolling in art school and, eventually, deciding to become an artist herself.

At Washington University, Fairchild almost certainly encountered Halsey Cooley Ives, a figure who would play a decisive, recurring role in her career.[4] Ives was a respected arts administrator whose contemporaries described him variously as "popular," "an imposing presence," and "one of the handsomest men in America."[5] Parallel terms were often used to describe Mary Fairchild throughout her long life. Ives founded the St. Louis School of Fine Arts in 1879 and became the first director of the St. Louis Museum of Fine Arts upon its creation in 1881. It would have been about this time that Fairchild and Ives began their initial three-year mentoring relationship. She won numerous awards for paintings at the school, although no work from this period seems to have survived. Beyond encouraging her artistic pursuits, Ives responded positively to a petition from Fairchild and her colleagues that apparently helped the women to secure permission to study from the nude model as part of their academic training. During these formative years in St. Louis, Fairchild also was instructed by Carl Gutherz, the Swiss-born muralist, who together with Ives subsequently promoted the 27-year-old artist for an extended scholarship to study in Paris from 1885 to 1888.

Fairchild's acceptance of the scholarship was a fateful one. She would not return to live again in the United States for almost another quarter century, and then it would be only after a painful divorce and with two young daughters in tow. Before leaving St. Louis, Ives advised Fairchild to enroll at the Académie Julian and to continue her work in life classes there, counsel that she followed explicitly. She listed Jules Lefebvre, Tony Robert-

Figure 2 *Mary Fairchild MacMonnies*, c. 1900. MacMonnies family papers. Photograph courtesy of E. Adina Gordon

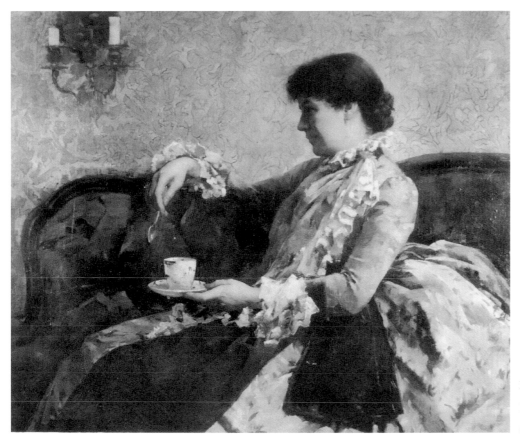

Figure 3 Mary Louise Fairchild, *Portrait of Mlle S. H. (Sara Tyson Hallowell)*, 1886. Oil on canvas, 38 1/4 x 44 inches. Cambridge University, Robinson College. Gift of Marion Hardy. Photograph courtesy of The Art Institute of Chicago

Fleury, and Gustave Boulanger as teachers in 1886. That summer she also traveled out to Picardie to paint *en plein air* with a group of students led by the British artist Harry Thompson.[6] As in St. Louis, she quickly impressed her European instructors and became a leading presence among the many foreign women who were studying art in France at this time.[7]

In 1886, Fairchild submitted her first picture to the Salon, and it was accepted (figure 3). The commissioned portrait of a fellow American, Sara Tyson Hallowell, reveals that Fairchild was a sophisticated artist with social connections to match. At 36, Hallowell was already a prominent figure in both Philadelphia and Chicago cultural circles who would, some six years later, play a key role in helping to secure an important commission for Fairchild at the World's Columbian Exposition. For the time being, the portrait established something still more important for Fairchild: Salon credibility. Between 1887 and 1891, she exhibited four more works at this important venue and even received a bronze medal for one of them.[8] Eventually at least two works by the artist were con-

sidered for purchase by official French institutions.[9] In 1889, Fairchild broadened her art studies and contacts by enrolling in the classes created especially for women with other prominent Parisian masters, including William-Adolphe Bouguereau at the Académie Julian, and, in 1890, with Carolus-Duran (Charles-Emile-Auguste Durand) and Luc-Olivier Merson at the Ecole des Beaux-Arts.

Apart from these mounting professional credentials, Fairchild was an active participant in the expatriate artist community that flourished in Paris around the turn of the century. Living at 53, rue Bonaparte, she and roommate Eurilda Loomis found themselves a short walk from their art school classrooms and at the virtual epicenter of Left Bank bohemian culture. Period photographs of Fairchild in her studio reveal a fashionably dressed woman, in an equally exotic space, with middle-eastern furniture, musical instruments, lay figures, easels, and after 1887, sculptures and drawings by Frederick William MacMonnies.

A Thanksgiving dinner that year served to introduce Fairchild to MacMonnies, and the two began a romance that led shortly to a shared residence and studio space in the 15th Arrondissement, at 11-16, impasse du Maine (now rue Antoine-Bourdelle). The fact that Fairchild elected to put off her marriage for several months, in order to take full advantage of the scholarship that was still being provided out of St. Louis, suggests both the pragmatic and free-thinking dimensions of Mary Fairchild's personality. Indeed, she was eminently practical in having recognized that survival in Paris depended upon the scholarship. (Ives had indicated that the funds would be immediately withdrawn if she married.) Equally, she was carefree in her disregard of any perceived loss of virtue brought about by the new arrangement where she, as a 30-year-old unmarried woman, had chosen to live and work with a man who was five years her junior. We can perhaps extend an interpretation of Fairchild's entire life in France according to these terms: she tended to be professionally cautious and, while not reckless, her personal life seems to have been unabashedly open and unfettered by conventions, especially as that life intertwined with Frederick MacMonnies. On September 20, 1888, just days after her scholarship expired, Fairchild and MacMonnies were married. They set off the same day for a honeymoon in nearby Cernay-la-Ville, a site that the two artists had previously discovered together and a popular destination for landscape painters during this period.[10]

1888 was one of the few years Mary MacMonnies failed to exhibit work at the Paris Salon. Through Hallowell, however, she apparently sent a single painting for exhibition to The Art Institute of Chicago. From 1888 on, her exhibition canvases grew in scale as she became increasingly interested in mythological subjects and highly personal genre painting experiments, often done in a *plein-air* manner. Paintings of mythological subjects, such as *The Young Juno*, appear in her exhibition records, and in this respect, her titles mirror those of her new husband's recently acclaimed sculptures. Nevertheless, whereas Frederick MacMonnies was consistently engaged by the rich history of the

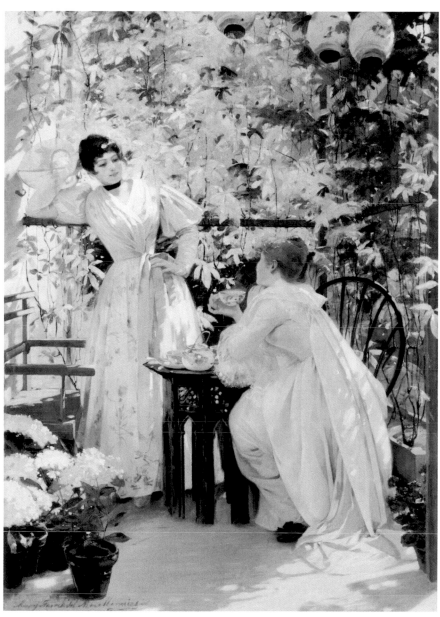

Figure 4 Mary Fairchild MacMonnies, *Between Neighbors (Entre voisines)*, 1891. Oil on canvas, 89 x 61 inches. Sheldon Swope Art Museum, Terre Haute, Indiana, 1961.08

monumental, classically-inspired themes that preoccupied sculptors of the *fin de siècle*, his painter-spouse was more innovative in terms of her pursuit of both contemporary and historically based subjects.

An index of the bold approach that Mary MacMonnies applied to her genre paintings can be taken from works such as *Between Neighbors (Entre voisines)*, 1891 (figure 4). The large—approximately 8 x 5 feet—canvas includes two almost life-sized female figures set in a bright, sun-splashed exterior patio. The small table that separates the women can be seen in photographs of the artist's studio, and its appearance here suggests that it was simply pulled out of doors as an accessory to an impromptu tea party on the shared courtyard at the Impasse du Maine. The identities of the figures lend further importance in this scene. The picture includes first and foremost a flattering self-portrait at left. The seated blonde female to the right seen in *profil perdu* has been identified as Pauline Clausade, whose husband, Louis Clausade, was a French sculptor.[11] Like Mary MacMonnies' own spouse, Clausade was a disciple of Jean-Alexandre-Joseph Falguière at the Ecole des Beaux-Arts. Thus the picture is highly self-referential. Additionally, the Japanese lanterns, the sensitive treatment of naturally filtered light, and the dazzling, decorative treatment of the garden space are reminiscent of John Singer Sargent's similarly large and celebrated painting, *Carnation, Lily, Lily Rose* (1885-86, Tate Gallery), which MacMonnies must have known at this time.[12] Her creative use of self, an affinity for female companions, her prized domestic props, and her reliance upon easily available sitters—to say nothing of citing recent vanguard experiments—became trademarks of MacMonnies' work throughout her French sojourn. *Between Neighbors* functioned as a veritable billboard for the artist's considerable talents. She exhibited it both in France at the Salon (where it was described as the "best picture painted by a woman"), and in the United States at The Art Institute of Chicago, The Corcoran Gallery of Art, and the World's Columbian Exposition between 1891 and 1893.[13] Clearly this painting represented a summation of the artist's public ambitions, which were (in the case of *Between Neighbors* at least) nothing short of monumental. At the same time, however, the canvas preserves a privileged view of an intimate encounter between women who by and large refuse to acknowledge the spectator's presence. In this respect it resembles the scene we encounter in the more diminutive, but no less captivating, later work, *Dans la nursery*.

The Breeze (figure 5) represents a seemingly opposite pole of MacMonnies' pictorial concerns during the 1890s. Only slightly smaller than *Between Neighbors*, but more tapestry-like in its treatment of compositional forms, *The Breeze* received considerable attention in both French and American art critical communities after its initial exhibition in 1895. Here the graceful, classically draped central figure is set against a deliberately heraldic color scheme. The work connotes the most admired, if conventional, decorative expectations of the period, yet at the same time is strikingly modern. A similarly lively treatment of a flowered background can be observed in the portrait of Sara

Hallowell. Indeed, the twirling form upon close inspection resembles more a contemporary portrait than an ideal subject. The work has previously been identified as a depiction of Isadora Duncan for this reason.[14] MacMonnies also claimed inspiration from a wide variety of contemporary sources in these early efforts at mural painting, most especially from the acknowledged leader of the movement in France, Pierre Puvis de Chavannes. To be sure, around this time she also painted full-scale replicas of frescoes by Sandro Botticelli at the Louvre. In *The Breeze*, however, she seems substantially indebted to Puvis' historicism, as well as to the basic renewal of interest in French wall paintings of this period.[15] In other historicizing panels, such as *Diana* (unlocated), exhibited the same year as *The Breeze* and imagined as its companion piece, MacMonnies demonstrated that her admiration for and emulation of this mural practice was a priority of her artistic production. These works led to her most important contribution to American art history, a mural titled *Primitive Woman*, which she developed between 1892 and 1893.

This mural was executed for the World's Columbian Exposition in Chicago and became the most celebrated of the artist's efforts to date, both in Europe and the United States. MacMonnies' prior professional and personal connections to both Ives and Hallowell played a decisive role in the commission, which was offered to her in the spring of 1892 by Berthe Potter Palmer, the President of the Board of Lady Managers for the world's fair. MacMonnies, together with Mary Cassatt, was chosen to be a principal muralist for the interior of Sophia G. Hayden's Woman's Building. The decision to select two American expatriates for the job of decorating this highly symbolic space had its own politics, to be sure, and seemed to require at least some justification. "To secure what she considered artistic abilities of a sufficiently high order was one of Mrs. Palmer's objectives in going abroad," according to at least one journalistic observer.[16] After selecting these two artists, Palmer turned over the responsibility of coordinating the program to Candace Wheeler, perhaps the most senior promoter of women artists in the United States.[17] In addition to MacMonnies and Cassatt, Wheeler supervised a young San Francisco sculptor, Alice Rideout, who decorated the exterior of the building, and gave mural commissions in other interior spaces to six other artists: Amanda Sewall, Lydia Field Emmett, Anna Lea Merritt, Rosina Sherwood, Lucia Fuller, and Dora Wheeler Keith. As much as any other building at the Jackson Park site, the Woman's Building was resplendent in its ornamentation, and pride of place had been given to the American artists then living in France.

Artists who worked in France at this time were unquestionably privileged participants at this, the last great American exposition of the nineteenth century.[18] There is some deep contradiction to be detected in this, since national art ideals and the event as a whole consistently and conspicuously were measured against European standards of success. Still, the two murals at either end of Hayden's impressively ornate "Court of Honor," like the rest of the fair's decorations, were interpreted as evidence of American cosmopoli-

Figure 5 Mary Fairchild MacMonnies, *The Breeze*, 1895. Oil on canvas, 69 x 52 inches. Terra Foundation for the Arts, Daniel J. Terra Collection, 1987.23. Photograph courtesy of Terra Foundation for the Arts, Chicago

Figure 6 Charles Dudley Arnold, *Columbian Fountain, World's Columbian Exposition, Chicago*, 1893. Bibliothèque du Musée d'Art Américain Giverny

tan achievement at the "White City."[19] The prominence given to these works, like the prominence given to women's participation in the fair, was double-edged, just the same. The creation of the Woman's Building was a result of the organizers' self-conscious decision to distinguish women artists, both symbolically and financially, from their male counterparts. Mary MacMonnies was paid approximately one-tenth of the amount that her husband received for his celebrated sculptural contribution to the fairgrounds, the *Barge of State*, an unavoidably central decoration that was more popularly known as the "MacMonnies Fountain" (figure 6).

The decision to separate women's culture from men's was a matter of no small controversy at the time.[20] Furthermore, the very placement of the building at the western edge of the official fairgrounds, in axial alignment with the midway's sprawling and dubious recreational elements, suggested the marginalization of this structure within the fair's overall scheme. Across every surface of the Woman's Building, the ideological stakes of

the decorative treatments ran high. We must imagine that this context of deliberate separation and disparity of recognition has important consequences for all the works contained within this particular structure, especially the works under consideration here. A brief comparison of Mary MacMonnies' decoration with the work done by Mary Cassatt yields numerous insights. The former had been approached first for the commission, and *Primitive Woman* seems to have been suggested to her as a theme by Palmer herself.[21] Cassatt was approached next and presumably had the subject of *Modern Woman* imposed upon her as a result of the timing. Both artists dealt with identical spaces measuring roughly 15 feet high by 65 feet long, although they were not given exact dimensions until quite late in the process. Ostensibly, MacMonnies had more established interest in creating wall paintings than Cassatt did in 1892. Indeed, the Chicago mural was a unique experiment for Cassatt, and one that was ultimately judged unsuccessful by the majority of contemporary critics who saw the work *in situ.* Publicly, *Modern Woman* was decried as "erratic" and even "cynical."[22] MacMonnies' effort, on the other hand, was "satisfactory to an unusual degree. The drawing is excellent and the entire plan shows a careful estimation of effect."[23] Curiously, although both women executed their works in France, there was very little dialogue between the two artists during the period when the works were being created.[24]

The interpretive drubbing that Cassatt's mural received is made more difficult to assess by the fact that neither mural survives today. Critics faulted Cassatt, who was better known in France as a member of the Impressionist group than she was in her native United States, on the grounds that her tympanum was not sufficiently decorative and legible. *Modern Woman*'s figures were characterized as too small, the pictorial space was too realistic, the colors were too bright, and the decorative borders too large. *Modern Woman*'s complex allegory was thus not "readable" as part of the essentially decorative expectations for this large exhibition space. MacMonnies' work was judged successful by just the opposite terms. Whereas Cassatt employed thick borders that divided her lunette into three discrete sections, MacMonnies painted a narrower floral band and placed her equally tripartite composition within a unified, if still flattened, pictorial space. Cassatt also dressed her figures in contemporary garb, while MacMonnies by her own account had "settled on the simplest draped figures of women, without special type of costume, in a landscape background that might be of any time or country and is certainly not un-American."[25] These pictorial choices were significant and were interpreted by the critics as evidence of an effort of qualitatively higher rank by MacMonnies. Will Hickok Low, himself a muralist, wrote of the difference between these two efforts: "Mrs. MacMonnies here leads the van with a composition sober in line and excellent in color. Miss Cassatt, having apparently defied the laws of decoration, has divided the space in three parts, in each of which she has painted pictures which, from her previous work, must be judged to be of excellent quality, but which, from the height at which they were seen and by reason of the small scale of the figures, are virtually lost."[26] Low's observation that the Chicago commission certified Mary MacMonnies' place

at the vanguard of turn-of-the-century civic art is born out by the sheer abundance of critical writing from the period devoted to this work. Even in relatively indistinct reproductions of the Woman's Building interior, the effectiveness of her conception seems clear (figure 7). These photographs record *Primitive Woman*'s placement at the north end of the hall, showing MacMonnies' confidence as a public artist, her success at composing an ambitious figural group in a wooded setting that remarkably seemed suited to its overdeterminedly modern, urban, exhortatory context. Augustus Saint-Gaudens' assessment that *Primitive Woman* was "the best decoration at the fair" seems not too inflated when read in this light.[27]

Mary MacMonnies spent about nine months working on scaffolds in her Impasse du Maine studio in order to complete this project.[28] Although the finished mural has been missing since about 1911, a small preliminary study for *Primitive Woman* was produced before the end of 1892. This work has recently been discovered in France, and it occupies a singular place in the present narrative (figure 9). Squared for eventual enlargement, and painted in muted colors that correspond to published descriptions of the finished lunette, the study provides the most direct visible access to MacMonnies' success in 1893. The same study appears on the rear wall of *Dans la nursery*, a work painted by the artist at least three years later, and half a world away from Chicago. Before attempting to analyze this unique reappearance of *Primitive Woman* within Mary MacMonnies' Giverny nursery/studio, it will be useful to trace the steps by which the important sketch came to hang on a nail in a village home at the border of Normandy and the Ile de France.

As noted above, no sooner were Frederick and Mary MacMonnies married in Paris than they set off to explore the nearby countryside. The first recorded notice of the two artists in Giverny appears in the Hôtel Baudy guest register on April 3, 1890. A postcard of the interior of the hotel from about this time shows one of Mary MacMonnies' pictures, *Lady with an Umbrella*, 1897, prominently placed on the rear wall (figure 8). The couple must have enjoyed that initial four-day stay at the inn, because just over one month later the two returned for a slightly longer visit.[29] These early visits put the MacMonnieses in the first wave of Americans who founded the art colony at Giverny in the decade after Claude Monet took up residence there in 1883. Along with Lilla Cabot Perry, they were also among the first Americans to rent summer residences in the village and among those few who decided to buy property in the Eure, which they did in 1901 after two long-term leases had expired.[30]

By the early 1890s, Monet had already grown impatient with a perceived loss of privacy at his village home, Le Pressoir (figure 10). Monet was, according to Claire Joyes, so "constantly harassed by young painters seeking lessons or advice he was finally forced to shut his doors to all but a select few."[31] This had little effect on the swelling number of American visitors to Giverny, however. Within a few short years, Frederick and Mary

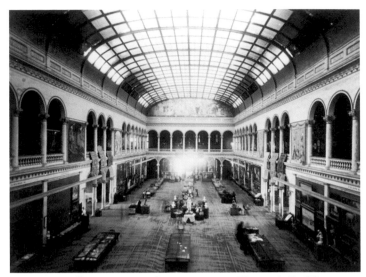

Figure 7 William Henry Jackson, *Interior, Woman's Building, World's Columbian Exposition, Chicago*, 1893. Chicago Historical Society, Chicago, ICHi-17136

Figure 8 *Interior of the Hôtel Baudy*, c. 1900. Bibliothèque du Musée d'Art Americain Giverny

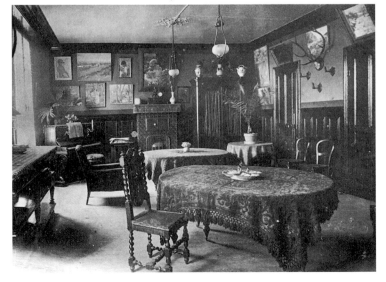

Figure 9 Mary Fairchild MacMonnies, *Study for "Primitive Woman,"* c. 1892. Oil on canvas. Private collection

MacMonnies came to play at least as consequential a role as Monet did in providing an excuse for Americans to spend time in this area. Indeed, many of the artists who were refused by Monet were, in turn, warmly welcomed at the MacMonnieses' first summer residence, the Villa Bêsche, which they began renting shortly after her return from Chicago. The second MacMonnies home, an abandoned priory that was jokingly known as the "MacMonastery," stood at the opposite end of the village from Monet's home, and, in stark contrast to the Impressionist's proper bourgeois household, functioned as an almost libertine country villa for the Parisian-American artistic community.[32]

Mary MacMonnies immediately invested herself in life at Giverny, perhaps even more so than her husband. By 1896, she was living an almost wholly independent existence in Giverny, together with her young child and servants—a governess, Marthe Lucas, and a child's nurse, known to us only by her first name Lili—for a substantial part of each calendar year. Certainly by 1898, at which time the MacMonnieses began renting the walled fourteenth-century structure called Le Moutier, the couple had virtually settled on a convenient life apart from each other. Frederick's fame as a sculptor had grown in the years since his triumph at the World's Columbian Exposition. His many public commissions, and the controversies that often surrounded these projects, had secured him the highest rank among contemporary sculptors.[33] He taught classes with James McNeill Whistler in Paris and traveled widely and so often that he found himself in Italy at the time of the birth of his second child, Marjorie Eudora MacMonnies, on October 18, 1897. The intrepid sculptor returned to Paris just ten days later, however, to attend the birth of his illegitimate son, Robertson, whom he had fathered with his long-time mistress, Helen Glenn.[34]

The precise stages of deterioration in the MacMonnieses' marriage are difficult to reconstruct from available documentary records. We know, however, that husband and wife spent almost an entire year apart in 1902—he in the United States, while she remained

Figure 10 Theodore Robinson, *Portrait of Claude Monet,* c. 1888. Cyanotype. Terra Foundation for the Arts, C1895.1.6. Photograph courtesy of Terra Foundation for the Arts, Chicago

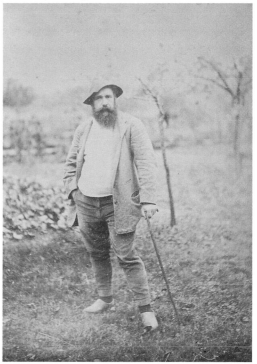

in France. One catalyst in the developing rift between the two artists might have been the death of their young son, Ronald, in 1901.[35] *Dans la nursery* provides its own form of testimony about Mary MacMonnies' attitude toward the family's shaky circumstances five years prior to that event. The painting reveals a great deal about the artist herself, despite the fact that she is not represented in it. Before embarking on any deep speculations about the hidden significances of the painting, however, it is perhaps useful at this point to return simply to what is shown and, then, maybe just as importantly, what is missing from the scene. *Dans la nursery* includes several paintings within the painting, at least one of which—the study for *Primitive Woman*—has already been identified. Its central, supervisory placement will be addressed at the conclusion of this essay. The lunette is supported by three slightly larger decorative panels that hang beneath it, as if to elevate the work to the highest possible place. Also present in the room is another picture that calls out for more immediate discussion: the small painting that rests on the easel at right. This work is identifiable, too, as a portrait of the MacMonnieses' first child, Betty, known as *C'est la fête à bébé* (figure 11). The work was shown as a companion piece to *Dans la nursery* at the Salon of the Société Nationale des Beaux-Arts in 1899. Within the realist fiction constructed by this group of representations, the artist creates a space that calls attention to the scene of painting. We must imagine her standing at another easel just beyond the space depicted in the painting, at work on a picture that ends up being *Dans la nursery*. We are asked to make sense of the painting as an illusionistic tour de force, but must first consider how the painting can be a record of something "real" when it is only an illusion, more or less compelling, and more or less constrained by temporal and spatial concerns. The dizzying, hall of mirrors effect—philosophers have named it *mise-en-abyme*—always amounts to a self-conscious circumscription of the representational act.[36] Indeed, the raised arm of Betty that we see in the finished work seems to be a direct reference to this particular mimetic problem. Waving or gesturing in emulation of her painter-mother, she signals the artist's presence within a still larger, unrepresented space, calling deliberate attention to the work's underlying self-referential mode.

There are, of course, important precedents for the *mise-en-abyme* treatment of studio spaces within the broader history of western art. The most important of these must be Diego Velázquez' *Las Meninas*, 1656, which we know held special significance for the MacMonnies family in these very years (see page 21).[37] Like *Las Meninas*, *Dans la nursery* shows a room with identifiable paintings arrayed on a distant wall. As does Velázquez, MacMonnies makes a young blonde child the nominal focus of her painting within a painting. The two works also share a pictorial conceit of figures within the composition who display various states of awareness about the actors who are understood to be standing outside of the pictured space—that is, in the place of the spectator. Such a shattering of boundaries between "the depicted" and "the act of depiction" accomplishes a major breakthrough in the history of modern consciousness, albeit more powerfully in the mid-seventeenth century than in the late-nineteenth century.[38] But we

Figure 11 (opposite) Mary Fairchild MacMonnies, *C'est la fête à bébé*, c. 1896-98. Oil on canvas, 15 1/8 x 18 1/4 inches. Terra Foundation for the Arts, Daniel J. Terra Collection, 1999.90. Photograph courtesy of Terra Foundation for the Arts, Chicago

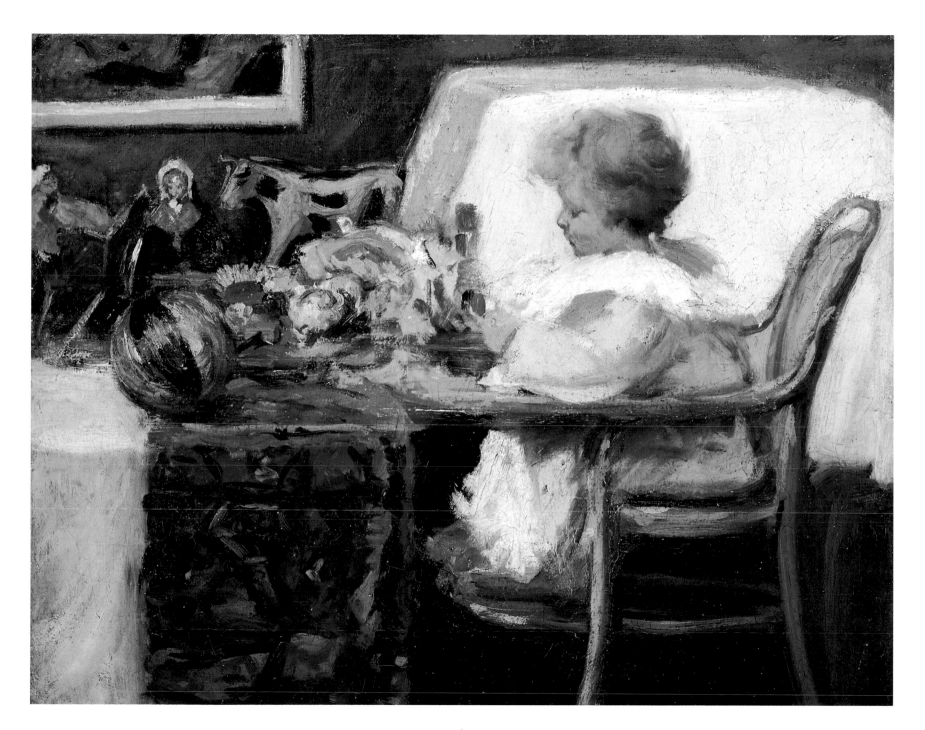

should be careful not to make too much of these similarities. The scale of paintings is completely different, of course, and in the Baroque masterpiece, the painter's portrait is significantly included within the representational space of the picture, while MacMonnies cues her own presence indirectly, both through her known works and through her daughter's acknowledging glance.

It hardly makes any difference whether we insist on a comparison between this work and the Velázquez. MacMonnies' painting makes its own subtle statement about the space in which painting takes place. One has only to compare *Dans la nursery* with another portrait done of an artist's family during these same years to note how atypical its construction truly is (figure 12). Jacques-Emile Blanche painted his portrait of the painter Fritz Thaulow at work just a few years before, and it is typical of the genre as it was then understood in France. The comparison of Blanche's thoroughly adulatory representation to *Dans la nursery* is useful because it points to the one figure who is conspicuously absent: Frederick MacMonnies.

Dans la nursery is suggestively silent about Frederick MacMonnies' place in the family drama that it represents. We should ask: "What purpose does an incomplete portrait of the artist's family serve?" In answering this question, perhaps we begin to intuit one of the key strategies of Mary MacMonnies' artistic practice. She had always worked more or less independently of her husband, and she rarely (and even then only indirectly) referred to his artistic interests in her paintings during the course of their twenty-year marriage.[39] Beginning in 1897, and even before that time, her works champion the life in Giverny that she led, increasingly, on her own. Mary MacMonnies was already a successful artist before she met her young husband, and she never showed signs of relinquishing her professional interests during their time together. As we have seen, she exhibited often and continued to receive high praise for her works.[40] It is tempting to suggest that the sculptor's phantom presence in her work might be less a function of willful forgetting than it is a reflection of his frequent physical absence from the place. Still, there can be no question that his failure to appear in his wife's paintings ultimately reflects upon his progressive estrangement from her as both an artist and as a partner in the family. It is curious to note that she and the couple's two young children appear in many of his uncommissioned paintings from these same years.[41] In any event, the couple's collapse was completed in 1909, when after lengthy separations, they legally divorced. When the end of their relationship finally came, it was predictably bitter, with Frederick MacMonnies excusing himself for all private misdeeds by having for twenty years "put everything within reach that money could buy to further his wife's artistic ambitions.... However it is quite over now."[42]

The pictures Mary MacMonnies painted in Giverny between 1897 and 1908 show her children, her close friends, and her household helpers—usually Marthe Lucas and Lili—in states of veritable domestic, even pastoral bliss. Views of Le Moutier's extensive gar

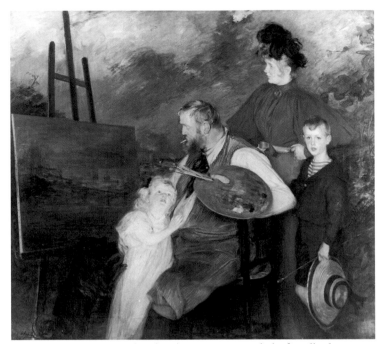

Figure 12 Jacques-Emile Blanche, *Le portrait de la famille du peintre Thaulow*, c. 1890. Oil on canvas, 70 7/8 x 78 3/4 inches. Musée d'Orsay, Paris. Photograph courtesy of the Reunion des Musées Nationaux

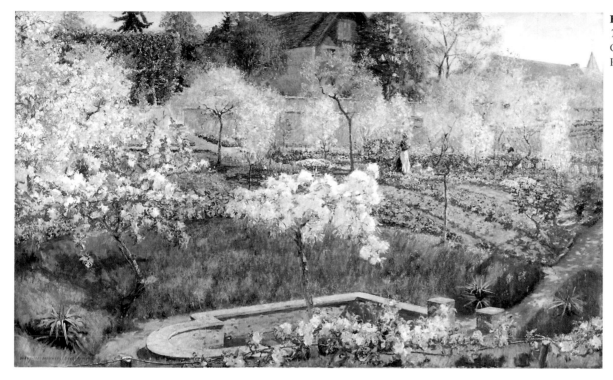

Figure 13 Mary Fairchild MacMonnies, *Blossoming Time*, c. 1901. Oil on canvas, 39 x 64 inches. Collection of the Union League Club of Chicago. Photograph, Michael Tropea

dens and basins constitute an important group of objects from these years. These pictures chronicle seasonal changes and, in so doing, attest to Mary MacMonnies' year-round presence in the village (figures 13-15). Both *Dans la nursery* and *C'est la fête à bébé* belong to an equally discrete series of pictures that MacMonnies seems to have initiated around 1897. This series includes *La Repriseuse* (private collection, France*)*, *French Nursemaid and Baby Berthe* (private collection, U.S.A.), *Lady with an Umbrella and Child* (private collection, France), *The Red Cloak* (Terra Foundation for the Arts), *Marthe Lucas, Betty and Marjorie* (private collection, France), and *Betty* (Hirschl and Adler Galleries, New York).[43] All of these images represent the same core group of sitters, and all of them celebrate the Giverny household's daily routines. The most important picture of this group is certainly *Roses et lys* which, unlike the rest, is clearly signed and dated (figure 16). *Roses et lys* focuses on 2-year-old Betty, who clings to her doll and smiles back angelically at the spectator from her place in the carriage. MacMonnies' self-portrait balances this sun-dappled garden scene, and the striped ball from *C'est la fête à bébé* reappears in the lower left corner. Like *Between Neighbors*, the large picture was displayed at the Salon, American museum annuals, and various world's fairs on an almost non-stop basis between 1897 and 1903, when it was purchased by the Musée des Beaux-Arts de Rouen for its permanent collection.[44]

Figure 15 Mary Fairchild MacMonnies, *Un coin de parc au temps de neige*, before 1904. Oil on canvas, 38 3/8 x 64 1/2 inches. Musée Municipal A.-G. Poulain, Vernon, 79.18

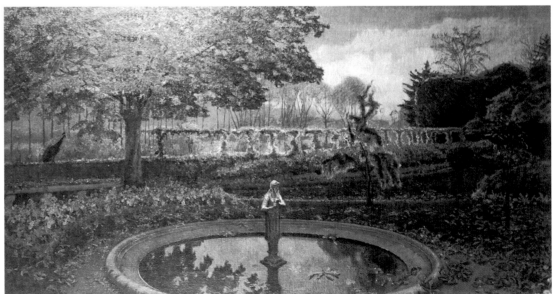

Figure 14 Mary Fairchild MacMonnies, *Garden in Giverny*, c. 1900. Oil on canvas, 29 3/4 x 55 inches. Sheldon Swope Art Museum, Terre Haute, Indiana, 1999.40

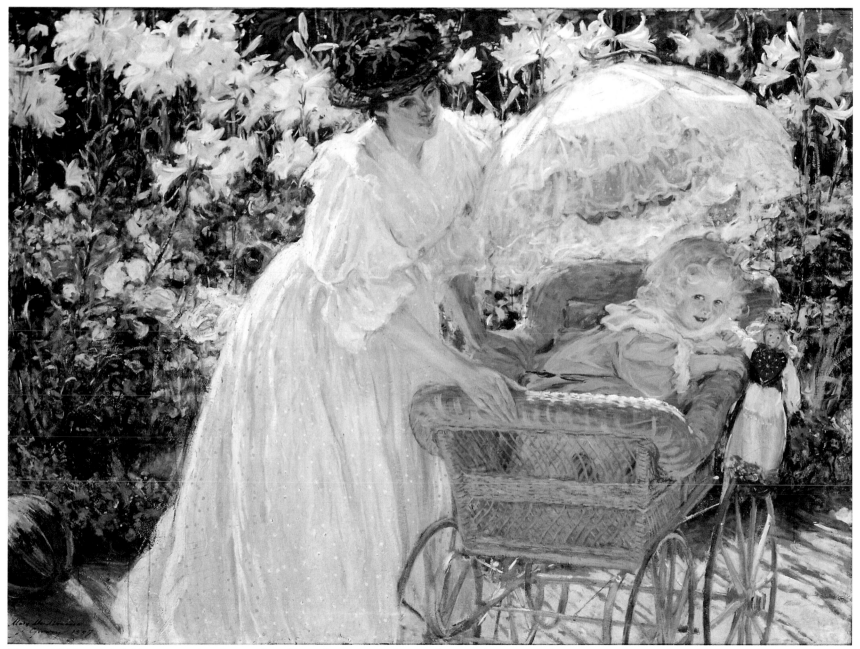

Figure 16 Mary Fairchild MacMonnies, *Roses et lys*, 1897. Oil on canvas, 51 1/4 x 67 1/4 inches. Musée des Beaux-Arts, Rouen.
Photograph, Didier Tragin and Catherine Lancien

An undated photograph of the Giverny studio affords a view of *Roses et lys* hanging on the same tapestry-covered wall that is visible in *Dans la nursery* (figure 17). The principal subject of the photograph is Betty, sitting and looking a little bit distracted in her carriage, together with her nurse, Lili, carefully assuming the role of Mary MacMonnies in the finished picture. With *Roses et lys* discernible behind these staged figures, the photograph represents a variant of the *mise-en-abyme* impulse already noted in the treatment of *Dans la nursery* and *C'est la fête à bébé*. Through these works Mary MacMonnies thus reveals her effort to treat the studio/nursery space as a special frame of reference. In her mature work, it was the privileged site for protracted reflection on the self, her work, and her family group, reflections that frequently took the form of carefully staged tableaux-vivants from which she could view these actors (including herself) from a distance. The resulting representations were aimed at better perceiving Mary MacMonnies' various roles, her selves. In fact, *Dans la nursery* is in this respect nothing short of a tour de force at combining the public and private spheres.

MacMonnies married her long-time friend, and fellow-muralist, Will Hickok Low almost immediately upon her departure from Giverny in 1909 (figure 18). The two continued to paint together in Bronxville, New York, where she exhibited exclusively under the name Mary Fairchild Low. She concentrated on garden scenes and received many local portrait commissions almost up until her death on May 23, 1946. The Lows never returned to Giverny, although the MacMonnieses' daughters maintained ownership of Le Moutier through the mid-twentieth century. Indeed, the split with Frederick MacMonnies amounted to an almost complete break with France for the family. For his part, Will Low associated the village in his poetic memoirs with a distinctly feminine encampment. "In my student days [the 1870s]," Low reminisced, "the young woman votary of art had made but a timid first appearance in Paris." By 1892, however, Low observed that "she had come in numbers so largely plural that the male contingent at Giverny was greatly in the minority."[45] Mary MacMonnies' paintings of this decade might be said to exaggerate these demographics still further. For her, Le Moutier amounted to nothing less than a second "Woman's Building," one that she had the power to arrange and to control with uncontested authority.

The public and private spheres of Mary Fairchild MacMonnies Low intersect and vie for attention in the composite space of her nursery/studio view. *Dans la nursery* is a stunningly summary work in this way. As a depiction of quiet nurturing and creative contemplation, the painting makes certain claims about the gendering of spaces available to this artist. From St. Louis, to Paris, to Chicago, to Giverny, the small picture encapsulates the career of its maker and measures her development both as a gifted painter and independent individual. Toward one end of the room, supervising the whole, hangs the study for her most important public project, a work that allegorizes the central role of women in traditional society as workers and mothers, and explicitly marginalizes the role of male figures. As if to further emphasize this fact, the top of the *chevalet* slices

Figure 17 *Lili and Berthe in the Studio*, c. 1897. MacMonnies family papers. Photograph courtesy of E. Adina Gordon

through and cuts off the right corner of the study—the only section in the finished mural where male activity takes place. Building on this theme of exclusion and self-sufficiency, toward the middle of the studio space, two contemporary women work with determination and thus reproduce the actions of *Primitive Woman* in their contemporary context. At the heart of the picture, Berthe refuses to be ignored. The baby gestures back eagerly toward the artist—mirroring her action as she calls continual attention to herself as the subject of the painting. Within this narrative suspension of time and space, we must then imagine MacMonnies momentarily stepping away from the easel to survey the whole range of possibilities before her, including the completion of this child's portrait. From such a distance, one that manages simultaneously to compress and to dilate the professional and personal concerns of this public artist, mother, and wife, we recognize Mary MacMonnies seizing her choices and training her gaze decisively both within, and beyond, these nursery walls.

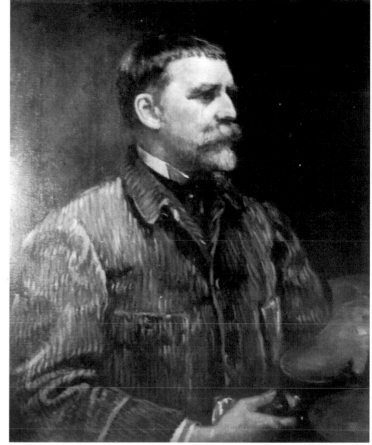

Figure 18 Mary Fairchild MacMonnies Low, *Portrait of Will Hickok Low*, 1911. Oil on canvas, 30 x 25 inches. National Academy of Design, New York

Notes

[1] Interestingly, the painting is neither signed nor dated. The child in the painting is identifiable as Berthe Hélène (Betty) MacMonnies, who was born in September 1895. Based on her portrait within the picture, a date of late 1896 is not entirely out of the question, although 1897 seems much more probable. A certain amount of confusion has surrounded the identification of this work. At one time it was assumed that the painting was by Frederick William MacMonnies, although the attribution to Mary MacMonnies now seems unquestionable. The painting corresponds to the work she contributed to the 1899 Salon of the Société Nationale des Beaux-Arts (no. 976), where it was exhibited under the title it now bears. Mary MacMonnies also showed a painting called *The Nursery* in several exhibitions in the United States in 1896, and, if the proposed early date is correct, this could be the painting. The location of the scene depicted has been also called into question recently. It is very likely set in Giverny, but doubt has been raised about this since, during these years, the MacMonnies family still maintained studios in Paris. The family began renting homes in Giverny in the summer of 1895, having been regular visitors to the Norman village since at least 1890. After 1897, Mary MacMonnies spent the great majority of her time in Giverny. A letter (August 21, 1991) in the curatorial files of the Terra Foundation for the Arts from Mary Smart to William H. Gerdts retraces the confusion over the work's attribution and argues persuasively for the dates used here.

[2] The MacMonnieses' second daughter, Marjorie, was born in October 1897.

[3] For details of Mary MacMonnies' biography, I have relied on numerous archival and published sources. The most important of these published sources has been Mary Smart, "Sunshine and Shade: Mary Fairchild MacMonnies Low," *Woman's Art Journal* 4 (Fall 1983/Winter 1984): 20-25. See also, Mary Smart, *A Flight with Fame: The Life and Art of Frederick MacMonnies*, with a Catalogue Raisonné of Sculpture and a Checklist of Paintings, by E. Adina Gordon (Madison, Conn.: Sound View Press, 1996), esp. 72-80; Ethelyn Adina Gordon, with *Avant Propos* and catalogue notes by Sophie Fourny-Dargère, *Frederick William MacMonnies et Mary Fairchild MacMonnies: deux artistes américains à Giverny*, exh. cat. (Vernon: Musée Municipal A.-G. Poulain, 1988); Eleanor E. Greatorex, "Mary Fairchild MacMonnies," *Godey's Magazine* 126 (May 1893): 624-32; and Arthur Hoeber, "American Women in Art: Mary Fairchild MacMonnies," *Ev'ry Month* (November 1896): 25.

[4] Fairchild would certainly have come into contact with Ives again in 1893 at the World's Columbian Exposition where she contributed her mural and where he served as Director of the Department of Fine Arts. Ives probably also played a role in the St. Louis Museum of Fine Arts' acquisition of works by this artist in the 1890s.

[5] Quoted in Carolyn K. Carr, "Prejudice and Pride: Presenting American Art at the 1893 Chicago World's Columbian Exposition," in *Revisiting the White City: American Art at the 1893 World's Fair*, exh. cat. (Washington, D.C.: National Museum of American Art, Smithsonian Institution, 1993), 68-69.

[6] Smart, *Flight with Fame*, 73; Greatorex, 630.

[7] Women paid roughly twice the fees that men did at this time to attend the Académie Julian. On the status of female art students in Paris at this moment, see Gabriel P. Weisberg and Jane R. Becker, eds., *Overcoming Obstacles: The Women of the Académie Julian*, exh. cat. (New York: The Dahesh Museum, 1999). The essential text on the art academies of Paris remains Albert Boime, *The Academy and French Painting in the Nineteenth Century* (London: Phaidon, 1971). See also, Veronique Weisinger, et al., *Le Voyage de Paris: les Américains dans les écoles d'art, 1868-1918*, exh. cat. (Paris: Château de Blérancourt, 1990); H. Barbara Weinberg, *The Lure of Paris: Nineteenth-Century American Artists and Their French Teachers* (New York: Abbeville Press, 1991); Lois Marie Fink, *American Art at the Nineteenth-Century Paris Salons*, exh. cat. (Washington, D.C.: National Museum of American Art, Smithsonian Institution, 1990); and Derrick R. Cartwright, *The Studied Figure: Tradition and Innovation in American Art Academies, 1865-1900*, exh. cat. (San Francisco: The Fine Arts Museums of San Francisco, 1988).

[8] Her *Self-Portrait* (1890, unlocated) received the award at the Exposition Universelle. See Smart, "Sunshine and Shade," 22, and Fink, 342 and 368.

[9] *Roses et lys* (1897, Musée des Beaux-Arts, Rouen) and *L'Arbre de Noel* (1899, unlocated). See Susan Grant, *Paris: A Guide to Archival Sources for American Art History* (Washington, D.C.: Archives of American Art, Smithsonian Institution, 1997).

[10] Mary Fairchild's painting, *June Morning* (1888, unlocated, previously in the collection of the St. Louis Museum of Fine Arts) was described in a 1915 handbook as a "kitchen garden in a French village (Cernay-la-Ville)." Winslow Homer painted in Cernay-la-Ville, for example, as did Dennis Miller Bunker. The MacMonnies-Fairchild courtship is described at some length in Smart, *Flight with Fame*, 72-76, and briefly in

Gordon, *Frederick William MacMonnies et Mary Fairchild MacMonnies*, 21.

[11] See Smart, "Sunshine and Shade," 22.

[12] Sargent's painting was appreciated by French critics after its initial exhibition at London's Royal Academy in 1887, and was later shown in Paris at the Exposition Universelle in 1889. See Marc Simpson, *Uncanny Spectacle: The Public Career of the Young John Singer Sargent*, exh. cat. (Williamstown, Mass.: Sterling and Francine Clark Art Institute, 1997), 155-56.

[13] Letter from Mary F. Henderson to The Corcoran Gallery of Art, dated February 8, 1892. Another letter, from Mary MacMonnies to F. S. Barbarini, curator at the Corcoran, dated April 3, 1893, requests that the painting be shipped to her former mentor Halsey C. Ives in Chicago for display at the World's Columbian Exposition. Both of these letters are in the curatorial files at the Sheldon Swope Art Museum, Terre Haute, Indiana. I would like to thank Laurette E. McCarthy, curator of American Art at the Swope, for making available to me copies of these and other documents related to their painting by MacMonnies.

[14] The identification is not as farfetched as it might initially seem. Duncan was briefly a neighbor of the MacMonnies family in Giverny.

[15] See Greatorex, "Mary Fairchild MacMonnies," 624, 630.

[16] Quoted in "Work of the Women: Services of Two Artists Secured by Mrs. Palmer," *Chicago Tribune* (June 11, 1892). Numerous articles have treated the circumstances and critical reception of the murals. Important among these are: Sally Webster, "Mary Cassatt's Allegory of Modern Woman," *Helicon* 9 (Fall/Winter 1979): 39-47; and Frances Pohl, "Historical Reality or Utopian Ideal: The Woman's Building at the World's Columbian Exposition, Chicago, 1893," *International Journal of Women's Studies* 5

(September/October 1982): 289-311. I have relied particularly on Judy Sund, "Columbus and Columbia: Man of Genius Meets Generic Woman, Chicago, 1893," *Art Bulletin* 75 (September 1993), reprinted in Mary Ann Calo, ed., *Critical Issues in American Art: A Book of Readings* (Boulder: Westview Press, 1998), 221-40.

[17] On Wheeler, see Kathleen D. McCarthy, *Women's Culture: American Philanthropy and Art, 1830-1930* (Chicago: The University of Chicago Press, 1991), 37-56.

[18] On the conflicts that took place over the overwhelmingly French expatriate presence at the fair, see Carolyn K. Carr, "Prejudice and Pride," 86-87.

[19] The literature on art at the 1893 exposition is truly vast. For contemporary appreciations of the Chicago Fair murals' significance for American artists, see Will H. Low, "The Art of the White City," in *Some Artists at the Fair* (New York: Charles Scribner's Sons, 1893), 59-80, and Pauline King, *American Mural Painting: A Study of Important Decorations by Distinguished Artists in the United States* (Boston: Noyes, Platt & Company, 1902), 62-81. See also Derrick R. Cartwright, "J. Alden Weir's *Allegorical Figure of 'Goldsmith's Art'* for the Dome of the Manufactures and Liberal Arts Building, 1892," *Bulletin: The University of Michigan Museums of Art and Archaeology* 9 (1989-91): 58-77.

[20] See Robert W. Rydell, "A Cultural Frankenstein?: The Chicago World's Columbian Exposition of 1893," in *Grand Illusions: Chicago's World's Fair of 1893*, exh. cat. (Chicago: Chicago Historical Society, 1993), 151-56.

[21] Palmer claimed authorship of the concept. "My idea was that we might show woman in her primitive conditions . . . either in an Indian scene or a classical one in the manner of Puvis, and as a contrast, woman in the position she occupies today." Berthe Palmer letter to Sara

Hallowell, February 24, 1892, as quoted in Sund, "Columbus and Columbia," 239-40.

[22] Quoted in McCarthy, *Women's Culture*, 103, and Sund, "Columbus and Columbia," 233. Negative appraisals of MacMonnies' mural exist as well, but disapproving judgments about Cassatt's effort far outnumber those interpretations. Berthe Palmer was one of Cassatt's great defenders. Palmer wrote to Cassatt admiringly upon seeing the works in Chicago, "I consider your panel the most beautiful thing that has been done for the Exposition, and predict for it the most delightful success." Quoted in Judith A. Barter, "Mary Cassatt: Themes, Sources, and the Modern Woman," in *Mary Cassatt: Modern Woman*, exh. cat. (Chicago: The Art Institute of Chicago, 1998), 96. MacMonnies installed her mural in Chicago and supervised the installation of her husband's fountain. During this time she made contacts with the journalists who swarmed over the fairgrounds. Cassatt remained in France, however, and her critical reception may have suffered as a result.

[23] "About the Studios," *Chicago Inter-Ocean* (March 12, 1893).

[24] See Carolyn K. Carr and Sally Webster, "Mary Cassatt and Mary Fairchild MacMonnies: The Search for Their 1893 Murals," *American Art* 8 (Winter 1984): 53-69. An exchange of letters between the two painters began in December 1892 and focused on the treatment of decorative borders. See Nancy Mowll Mathews, ed., *Cassatt and Her Circle, Selected Letters* (New York: Abbeville Press, 1984), 243-44.

[25] "Work of an Artist," *Chicago Tribune* (April 22, 1893).

[26] Low, "The Art of the White City," 78.

[27] Saint-Gaudens to Frederick MacMonnies, undated letter, Archives of American Art, 3042.

[28] "The Primitive Woman," *New York Recorder* (March 5, 1893). In another published report,

MacMonnies claimed to have worked for about two years on the mural, which is a slight exaggeration, since she had in fact received the initial invitation from Palmer in early 1892. See "Mrs. Frederick MacMonnies," *Chicago Times* (June 6, 1893).

[29] See Carol Lowrey, "Registre de l'Hôtel Baudy," in William H. Gerdts, *Giverny: Une Colonie impressioniste* (Paris: Abbeville Press, 1994), 223. See also, Claire Joyes, "Giverny's Meeting House, The Hôtel Baudy," in David Sellin, *Americans in Brittany and Normandy, 1860-1910*, exh. cat. (Phoenix: Phoenix Art Museum, 1982), 97-103.

[30] See Gerdts, *Giverny*, 132.

[31] Claire Joyes, *Monet at Giverny* (New York: Mayflower Books, 1974), 26. On Monet's skeptical regard of Americans in Giverny, see also, Derrick R. Cartwright, "Edito," *MAAG* 1 (Fall 1999): 1.

[32] Numerous accounts of the ribald, fairly eccentric group that constellated around the MacMonnies residence exist. See, for example, Sara Dodge Kimbrough, *Drawn from Life* (Jackson, Miss.: University Press of Mississippi, 1976), esp. 66-71; Sellin, *Americans in Brittany and Normandy*, 80; and Rosalie Gomez, *Impressions of Giverny: A Painter's Paradise, 1883-1914* (San Francisco: Pomegranate Artbooks, 1995), 85.

[33] See Robert Judson Clark, "Frederick MacMonnies and the Princeton Battle Monument," *Record of The Art Museum*, Princeton University, 43 (1984): 7-59.

[34] Frederick MacMonnies had been involved in a not entirely secretive affair with Glenn since 1890. See Smart, *Flight with Fame*, 182-90. Many of his closest friends, including Augustus Saint-Gaudens, ultimately spoke against MacMonnies out of disgust for his conduct in this affair. See Homer Saint-Gaudens, ed., *The Reminiscences of Augustus Saint-Gaudens* II (New York: The Century Company, 1913), 15-16.

[35] Smart, *Flight with Fame*, 202.

[36] See Jacques Derrida, *The Truth in Painting* (Chicago: The University of Chicago Press, 1987).

[37] On the endless fascination provided by Velázquez' masterpiece, see Jonathan Brown, *Images and Ideas in Seventeenth-Century Spanish Painting* (Princeton: Princeton University Press, 1978), 87-90, and John Shearman, *Only Connect— : Art and the Spectator in The Italian Renaissance* (Princeton: Princeton University Press, 1992), 261. See Joyce Robinson's essay in this catalogue for a more complete discussion of this work's significance for Frederick MacMonnies.

[38] See Michel Foucault, "Les suivantes," in *Les Mots et les choses* (Paris: Editions Gallimard, 1966), 19-31.

[39] A late exception to this rule is the large picture that Mary MacMonnies painted in 1908 of Frederick MacMonnies' *Barge of State* at the Chicago 1893 exposition. A reproduction of this painting appears in Clark, "Frederick MacMonnies and the Princeton Battle Monument," 64.

[40] Between 1900 and 1909, MacMonnies received no less than seven prizes—including four gold medals—for the paintings she had shown at international exhibition venues. She also served a three-year stint as president of the American Woman's Art Association in Paris. See Smart, *Flight with Fame*, 201.

[41] Importantly, *Monsieur Cardin*, 1900-1901, which shows both Mary and Marjorie in the left middleground, and a view of Mary MacMonnies' copy of Botticelli's frescoes in its background; *Mrs. Frederick MacMonnies and Children in the Garden of Giverny* (1901); as well as, of course, *The French Chevalier* (1901).

[42] Frederick MacMonnies to Mary MacMonnies, early 1909, quoted in Smart, *Flight with Fame*,

225. It is significant that when confronted with his family's final departure from France, he wrote to a friend: "I am much depressed & heavy hearted just now as my two little darlings are going to America with their mother." As if unconvinced by his own words, he continued to write, but then crossed out the next phrase: "I really can't tear them away from their mother." According to Gordon, the most pressing reason for the dissolution of the MacMonnies' marriage was Frederick's latest paramour, Alice Jones, whom he later married. See Gordon, *Frederick William MacMonnies et Mary Fairchild MacMonnies*, 25-26.

[43] Visual references to most of these paintings can be found in Gordon, *Frederick William MacMonnies et Mary Fairchild MacMonnies*, and Gordon, "Checklist of Paintings."

[44] François Bergot, *Musée des Beaux-Arts de Rouen: Guide des collections XVIIIe, XIXe et XXe siècles* (Paris: Reunion des Musées Nationaux, 1994), 124-25.

[45] See Will H. Low, *A Chronicle of Friendships, 1873-1900* (New York: Charles Scribner's Sons, 1908), 446. Low made thinly veiled references in his book to his growing affection for Mary MacMonnies: "[S]ince those days, I have passed a golden summer there, sheltered within garden walls in the gracious society of a *châtelaine* and two charming *filleules*" (450). Low's first wife had been a close friend to Mary MacMonnies, and this seems to have played a role in their decision to marry quickly. See Smart, *Flight with Fame*, 227.

Opposite: Frederick William MacMonnies, *Mrs. Frederick MacMonnies and Children in the Garden of Giverny*, 1901 (detail)

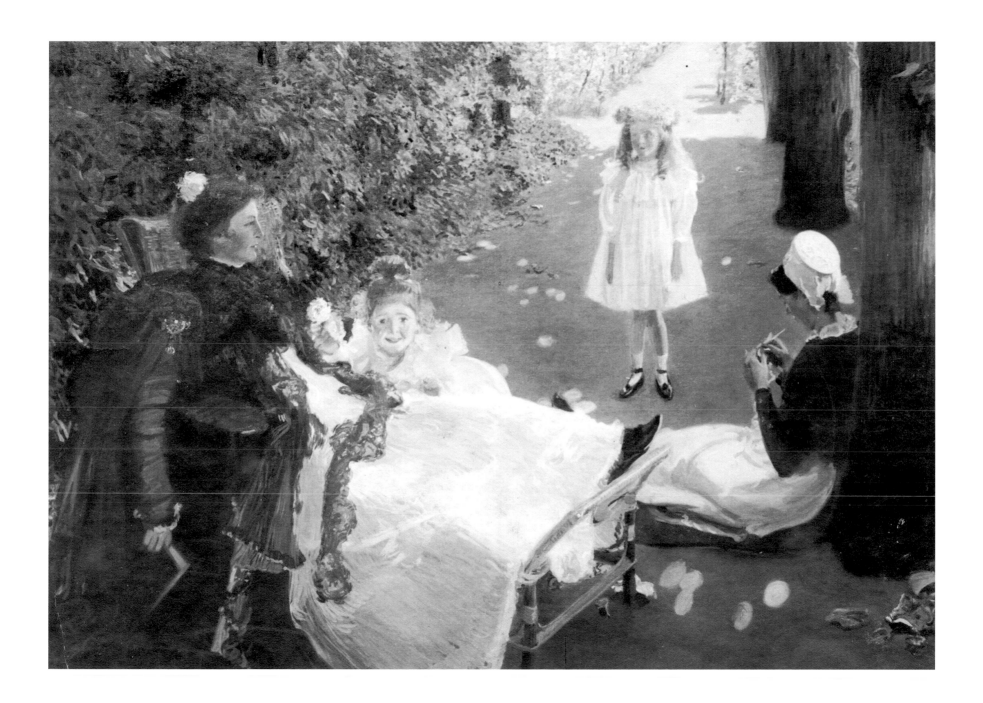

The Expansion of a Career: Frederick MacMonnies as a Teacher and Painter

E. ADINA GORDON

Introduction

The international success Frederick MacMonnies achieved as a sculptor with his colossal fountain at the World's Columbian Exposition in Chicago in 1893 had a greater impact on the artist's career than is universally acknowledged.[1] Certainly, it brought him fame and new commissions, but it also generated a succession of sculptors—and even painters—who sought him out as a teacher. After assuming this role, and partly as a result of it, he began to paint. I base this statement on my analysis of MacMonnies' sculpture and paintings and scrutiny of the records of those who claimed him as master and whom he claimed as students.[2] Received wisdom has it that MacMonnies' shift to painting was characterized as a "breakdown" at the end of a frenzied decade of creating monumental sculpture (1890 to 1900), when "no sculptor ever accomplished the same amount of good work in the same brief period."[3] In fact, it occurred between 1896 and 1897 at the peak of his creativity. The seeds of change go back to his sculpture ateliers, when MacMonnies and his assistants had already forged bonds of loyalty. His was a gregarious personality, generous of nature and responsive to admiration. He readily acquiesced to the pleas of students—in particular, women— that he train them and critique their work. Accepting his first student opened the path to his teaching and led to his involvement in informal teaching groups and two formally organized academies. Many students adored him; most regarded him with respect as their master. The sculptors in particular demonstrated this in their Salon submissions while, or shortly after, they were his students.

While it is acknowledged that his sculpture students owe much to his example as the progenitor of the genre of garden and fountain sculpture in America, a study of his influence as a teacher and painter has yet to be written.[4] More than a few students became his friends and members of his inner circle of artists, architects, and well-to-do patrons.[5] Artistically an energetic and inveterate draughtsman who had never quite given up the ambition to be a painter, he sketched and painted with them for his own delight. This

Figure 1 (opposite) *Frederick MacMonnies, Enid Yandell, Janet Scudder, and other students with a nude female model,* 1895-96. Photograph courtesy of Elsie Trask

activity began at the family residence in Giverny as a diversion during breaks from work in Paris. His teaching was thus a little-recognized but important contributing factor to his brief fling with painting full-time. Giverny grew in importance to him and became the venue for painting and teaching after the dozen years of his most intense sculptural output in which he "did his most impressive work."[6] The interaction of MacMonnies' painting students with each other and with him is an important subtext to his and their paintings of this period. MacMonnies turned to portraiture as a livelihood for only a brief time, whereas most of his students settled into long careers of making portraits of the rich and famous. This investigation looks at MacMonnies through a new lens in his changing role from bright star of American sculpture to teacher and painter.

The Sculptor, his Studios, and Assistants: Homage and Loyalty

MacMonnies' renown as a sculptor blossomed with his stunning achievement at the Salon of 1891, when he won the most significant prize yet received by an American, a second-class gold medal (the highest honor available to a foreigner) for *Nathan Hale* and *James S. T. Stranahan*.[7] These and his *Diana* were made at his studio at 16, impasse du Maine in Montparnasse, an appealing and affordable artists' enclave that attracted many of his and Augustus Saint-Gaudens' associates and students as a residence (figure 2). Creating and assembling the multi-figure allegorical fountain group for the Columbian Exposition required more space and a large workforce. MacMonnies rented an additional large atelier near the railway station in Montparnasse at 14, rue de l'Arrivée. There, in the manner of Saint-Gaudens, his first master, he gathered a team of assistants and skilled artisans. Most important to him were Louis Clausade, the enlarger Léon Grandin, François Tonetti, and John Flanagan.[8] As students of Jean-Alexandre-Joseph Falguière at the Ecole des Beaux-Arts, Grandin and Tonetti each had won honorable mention at the Salon of 1888, though each called themselves pupils of MacMonnies in their subsequent submissions.[9] Their homage to him typifies the loyalty he engendered all his life from numerous assistants and students.

Tonetti was MacMonnies' close friend and confidant for at least a dozen years.[10] In style and expressive content, his ideal private sculpture and monumental public works bear unmistakable testimony to the influence of MacMonnies. In Tonetti's *Gooseboy*, 1903 (figure 3), the youth bears the same puckish, near-adolescent mien as MacMonnies' *Standing Cupid*, 1895 (later miniaturized in the ivory *Cupid*, 1898, see page 15). Tonetti's schematic elements of youth and bird echo those in MacMonnies' *Boy and Duck Fountain* (or *Boy and Goose*), 1896 (figure 4).[11] However, by placing them in inverse proportions, he created a Hellenizing, monumentally scaled bird and, characteristically, lost touch with MacMonnies' essentially synthetic American Renaissance style.[12]

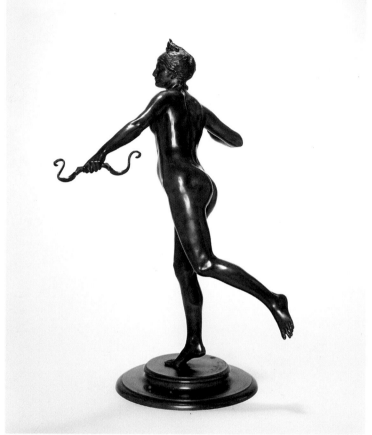

Figure 2 Frederick William MacMonnies, *Diana*, 1894 (original 1889). Bronze with golden patina, 30 1/2 x 20 1/2 x 16 1/4 inches. Terra Foundation for the Arts, Daniel J. Terra Collection, 1988.21. Photograph courtesy of Terra Foundation for the Arts, Chicago

When MacMonnies left Saint-Gaudens' studio in 1884 to pursue his studies in Paris, John Flanagan had taken his place and was in turn inspired to continue his studies in Paris at the Ecole.[13] In 1891 and 1892, while enrolled there and studying under Falguière, he worked as MacMonnies' assistant. Flanagan set up his own studio at 16, impasse du Maine, where MacMonnies later sketched him for a portrait toward the end of 1897. At the time Flanagan was working on his commission for the monumental clock for the domed Reading Room of the new Library of Congress in Washington, D.C.[14] In MacMonnies' over-life-sized painting, *John Flanagan, Esq.*, c. 1901 (The Newark Museum), Flanagan is seen sitting on a scaffold, studious-looking and bespectacled, a cast of the clock's winged Father Time with scythe hovering above him.[15] With increasing frequency between 1897 and 1901 MacMonnies made non-commissioned and often ambitious portraits of assistants and students. He inspired strong feelings of loyalty as evidenced by the portraits of him that many of them made in painting, bas relief, or sculpture. Certainly, it was not unusual for artists to exchange portraits. Thirty years later, Flanagan, by then one of the leading medalists of America, received this painting from MacMonnies in return for the portrait medallion he made of MacMonnies (The Newark Museum).[16]

Figure 3 François Tonetti, *Gooseboy*, 1903. Executed for the Scarboro estate of V. Everit Macy. Tonetti Family Archives

American Art Students flock to France; Janet Scudder seeks out MacMonnies

France, long a mecca for art, saw increasing numbers of American travelers, collectors, artists, and students flocking to Paris as the century wound to an end. Aspiring American artists crowded the streets and vied for places in the academies and ateliers. The Ecole des Beaux-Arts, open only to men until 1897, offered the most comprehensive art education. With its stiff entrance requirements, only the hardiest survived the narrow views, rigorous training, and dogged protectionism practiced by the chief professors, especially in the last quarter of the nineteenth century.[17] Other teaching academies (Académie Julian and Colarossi's) were the most popular and the most crowded. Mary Foote, MacMonnies' pupil, who later would become his disciple and lover, decried the Colarossi atelier filled with cigar smoke and reeking of turpentine and crowded to suffocation.[18] Most American artists arrived with shallow pockets and great expectations as they sought private ateliers, academies, life-drawing classes, and instruction—what they called "criticism"—from a known artist, particularly a French academician.

Figure 4 Frederick William MacMonnies, *Boy and Duck Fountain* (or *Boy and Goose*), 1896. Bronze, approx. 47 inches high. MacMonnies family papers. Photograph courtesy E. Adina Gordon

One sculptor, Janet Scudder, traveled to France with a burning desire to study with an American.[19] After studying at the Cincinnati Academy of Art, poverty forced her move to Chicago to seek employment.[20] There, she found work from 1891 to 1893 with Lorado Taft, sculptor and instructor at The Art Institute of Chicago. Initially, he hired her to assist in pointing up his sculpture groups for the Horticultural Building at the 1893 World's Columbian Exposition. Charged with enlarging all the sculptors' models sent for archi-

tectural decorations and fountains, and desperately requiring a large crew, Taft hired women, whom he dubbed his "white rabbits."[21] Among them were Scudder, Enid Yandell, Caroline Brooks, and Clio Hinton Huneker, all future students of MacMonnies.[22] The sight of MacMonnies' *Barge of State* being assembled in his *Columbian Fountain* on the fairgrounds galvanized Scudder, but she was shy and could not approach the sculptor, who was "watching the work with interest." Her words uncannily presage the remarks of several women in the next decade:

> But at that moment I knew that he was the one—and the only one—that I must study with in order to learn how to do the things I was burning to do. I must be his pupil. I must. I must. No one else in the world would be able to teach me sculpture.[23]

Scudder pursued MacMonnies to Paris early in 1894, with Lorado's sister, Zulime Taft, as companion and a letter of introduction from a friend in Chicago in hand. At their apartment, Mrs. MacMonnies (the former Mary Louise Fairchild, who had married Frederick in 1888) turned Scudder away. Despairing and penniless, she actually discovered the impasse du Maine studio address in a chance encounter with a friend from Chicago, the newly married Edith Woodman Burroughs and her artist husband, Bryson. At the door of the studio she pleaded with MacMonnies to accept her as his pupil. To their mutual surprise, he agreed and issued the dictum he later drummed into all his students, "You must draw, draw, draw —all the time—all day—all night—until you know you can draw to the very best of your ability." Anatomy, he thought, was what "every student must study...and then...forget."[24] He set Scudder to copying *his* drawings, such as *The Cobbler*, 1885, which had won the prize by acclamation when exhibited in Falguière's studio in 1886 (figure 5). After weeks of drawing lessons, he recommended life drawing at Colarossi's, which Scudder found inadequate.

"Atelier des Anges," the Académie Vitti, and the Académie Whistler

Scudder convinced her new mentor to give private weekly criticisms in drawing to a group of student-friends who "took a small studio, [and] employed a model" in the early spring of 1894.[25] With her in the "*Atelier des Anges*" (derisively named by the professional model), were three young women who became sculptors and whose work will be discussed below: Edith Burroughs, Katherine Abbot, and Enid Yandell.[26] Matilda Brownell, a young woman of means and social standing, who was destined to be an important ally of Scudder's, also joined them. She outlined the arrangement to her beloved painter-friend in New York, Lydia Field Emmet, describing MacMonnies in the same glowing manner many of his female students would use for years to come:

> This last week or so I have been drawing from life in the afternoons too—in a studio with [Yandell, Scudder, and Taft] and their friends [and] Miss Abbot, who has

Figure 5 Frederick William MacMonnies, *The Cobbler*, 1885. Charcoal on buff colored paper, 22 x 18 3/4 inches. The Metropolitan Museum of Art. Gift of Frank W. Stokes, 1948

had two pictures in the Champs de Mars and <u>no pull</u>. We have one of the best models in Paris—and on Saturdays Mr. MacMonnies comes in and criticizes us—all for love, if you please! He is very like Paderewski in looks and in that impression one can't fail to believe that he has genius in him. He dreams magnificently.... He seems frightfully nervous, a tall, thin, fair man of thirty with curly hair and an eternal cigarette. His criticisms are <u>fine</u>.[27]

A year later, with more women clamoring for instruction, Marie Caira (now Madame Vitti), the model for his *Diana*, opened the Académie Vitti. She persuaded MacMonnies, one of the many artists for whom she had posed when she was young, to criticize students' drawings. The girls of the *"Atelier des Anges"* joined his crowded life class of thirty American and English girls.[28] Eventually, hundreds of women studied with him there, including painters Josephine Miles Lewis and Lydia Field Emmet, and sculptors Mabel Conkling and Helen Farnsworth Mears, who will also be discussed below. Newspapers in French and American cities published an engraving of a photograph of MacMonnies drawing at an easel, surrounded by his students.[29] In a related photograph there is an addition: the all-important nude female model stands ignored, iconic, and in stark contrast to the twenty-nine girls in Gibson blouses ranged in a semi-circle around their teacher (figure 1). MacMonnies had made several large studies of models like this in his student days and often reiterated, "every sculptor should paint and draw and every painter should model in clay" (figure 6).

A number of years earlier the artist had insisted to his good friend Stanford White, "I can paint as well as I can do sculpture."[30] This conviction strengthened with his ever-increasing involvement in guiding sculpture and painting students and, by the spring of 1897, in painting alongside them. While he was teaching at the Académie Vitti and working at a feverish pitch creating monumental sculpture for lucrative commissions, MacMonnies began to paint for pleasure and profit. His oil sketches for *Atalanta*, 1895-96, the three-panel scene commissioned by White for the main stair lobby of his Madison Square Garden, were the first works inaugurating that new phase of painting.[31]

The Académie Whistler, also called the Académie Carmen, opened with much attention from the international press in September 1898 and featured James McNeill Whistler and MacMonnies as teachers. At this latter stage in Whistler's life, the two artists were close friends. As with Madame Vitti's academy, it was the brainchild of a model, Carmen Rossi, who had posed for Whistler since childhood. Students flocked to attend, and many were turned away before Whistler made his grand entrance from London two weeks late. Now accustomed to teaching, as Whistler was not, MacMonnies was amused:

Figure 6 Frederick William MacMonnies, *Study, Standing Female Nude in Profile*, 1885. Pencil on paper, 24 3/8 x 12 5/8 inches. The Metropolitan Museum of Art. Gift of Mrs. Gerret van S. Copeland, 1987

He had agreed to teach; a thing he always said was shocking, useless, and encouragement of the incapable. He suggested I help him out with teaching the sculptor pupils and the drawing, so I gladly agreed and looked forward to high larks.[32]

The school closed after three years due to Whistler's indifference and Carmen's lack of business acumen. Richard Farley, who became a painter of landscapes and beach scenes, was delighted to have come to Paris in time to enter the school. After one criticism from each, which he liked very much, he wrote,

> Mr. MacMonnies' criticism was from a sculptures [sic] standpoint. He wished us to see the figure in a more simple and bigger way, to get more of the feeling of sculpture and architecture [which] I do not appreciate enough. I feel his influence will be very good. Whistler did not disappoint me. I feel their influence will combine so well.[33]

When artists listed Whistler as their teacher in Salon catalogues, they were referring to this school. Years later, MacMonnies recalled two students in particular from the Académie Whistler, Albert Herter and his wife, Adele. His adventures with Whistler left vivid impressions on MacMonnies, and he associated the Herters with the social events they had shared with the MacMonnieses and Whistler.[34]

Scudder: from Student to Assistant; Paves the way for American Men as Student-Assistants

As his sole sculpture-atelier student beginning in 1894, Scudder modeled moldings and sphinxes on the tripod pedestal of a cupid and progressed to the figure for the popular bronze statuette *Standing Cupid*, 1895, that MacMonnies later used as the model for the multi-media *Cupid*, 1898.[35] Learning on the job, she worked on a succession of MacMonnies' commissions: decorations on the *Shakespeare* cloak, the wings on *Victory* for the *West Point Battle Monument*, and a new cast of *Bacchante* for the French government's purchase for the Luxembourg Gardens (see page 9).[36] Talented and now trained, she advanced to a salaried position. Confident of her ability, MacMonnies sent her to the rue de l'Arrivée studio to work out the details on the next three heroic-sized horses (after his model of the first horse) for *Quadriga* for the top of the *Soldiers and Sailors Memorial Arch* at Grand Army Plaza in Brooklyn.[37]

Although she described difficulties with Tonetti, one of MacMonnies' assistants, during this period, they met in New York years later and laughed about "jolly times…in Mac's studio."[38] From her own account, Scudder's relations with other men in the large atelier were not always smooth. As a novice and a woman, she had entered a professional atelier of skilled artisans, some of whom were sculptors in their own right; she was a natural target for jealousy and criticism. Despite MacMonnies' manifest confidence in

her, she was easily shaken by the jibes of an assistant who led her to believe that MacMonnies disapproved of her work. Diffident and shy, she could not imagine discussing the situation with MacMonnies and abruptly announced her departure for New York, where she would try to earn her living as a sculptor. Accepting without understanding her problem, MacMonnies gave her letters of introduction to his close friends, Saint-Gaudens and White.

She was desperate to work, but the letters did not have the desired effect. Always generously seeking employment for male assistants and friends (as did MacMonnies and White), Saint-Gaudens wrote, "For my peace of mind, send me no more Miss Scudders with such letters, *nom de dieu*."[39] When White off-handedly referred to Scudder months later, MacMonnies shot back sarcastically, "I am glad to hear that you are all so kind to Miss Scudder. As I wrote St. Gaudens, who is joining the great majority of admirers of *le beau sexe*, there has been a long and loud triumph of male mediocrity. Surely the girls can't do worse. Why not let them have a shy at it-besides being polite on our parts?"[40] Driven by need, she revisited Saint-Gaudens. He again refused her a place in his atelier, but gave her a treasure: a set of letters of the artistic alphabet he had designed for his reliefs.

The long-term relationship between Scudder and MacMonnies involved reciprocal benefits, and they assisted each other professionally. (She acted as his agent in the field in America for his statuette, *Theodore Roosevelt,* 1905.[41]) Having made great strides as a sculptor under his tutelage, she gained the confidence to work only on her own creations from then on. She was proud to cite him as her master throughout her working life. Nonetheless, her career was not yet established, nor had it taken form when she returned to France two years later in 1898. Her work and the direction it took will be discussed below. Scudder had persuaded MacMonnies to undertake teaching, and her assistantship influenced him to continue the role of master-sculptor in his atelier. He accepted three male trainee-assistants by mid-1896, shortly after her departure: Conrad Slade, John Roudebush, and Paul Conkling.[42] Little is known of Slade, save that he worked under MacMonnies' tutelage from 1896 to at least the end of 1898.[43]

MacMonnies was particularly attached to Roudebush, an explorer and hunter who shared his enthusiasm for sports and who had a brief career as a sculptor.[44] He was in the studio by 1896 and produced one known sculpture, *Boxeurs,* which won honorable mention at the 1898 Salon. The catalogue cited MacMonnies as his teacher.[45] Roudebush was already in New York when the dynamic two-man group, redefined as wrestlers and titled "*Lutteurs,*" won a bronze medal at the Universal Exposition in Paris in 1900.[46] It was before Roudebush left France, however, that MacMonnies painted *John H. Roudebush, Esq. (Portrait de M.R.),* 1898-1900 (private collection). Posed as a hunter with the gunstock tucked under his right elbow, Roudebush is shown turned three-quarters to the left looking at the viewer. MacMonnies repeated this compositional

format in his last period of painting from 1927-31 in his portraits of *Frederick Finn*, 1927 (Finn Family Collection), and *Colin Farquhar in Riding Costume*, 1930-31 (Collection of John Farquhar).[47]

After more than a year as a trainee, Paul Conkling gained the confidence of MacMonnies, who allowed him to model the spouting turtles for *Boy and Duck Fountain* (figure 4). He sent Conkling to Brooklyn to oversee the complicated plumbing for the figure and the installation of the fountain in Prospect Park.[48] The three men had been training under MacMonnies only a half year when the next female student with a burning desire to study with MacMonnies, Ellen Gertrude Emmet (Rand), called "Bay," was also allowed to work at the impasse du Maine studio.[49]

In December 1896, Bay Emmet, who had worked as an illustrator in New York, stopped in London with her sisters Rosina Hubley Emmet and Edith Leslie Emmet on her way to Paris to study art. Rosina went on to Paris with Bay. Leslie, as she was called, joined them later. These sisters had three first cousins; two of them, Rosina Emmet Sherwood and Lydia Field Emmet, were accomplished artists and were older than Bay and her siblings. Rosina and Lydia's younger sister, Jane Erin Emmet, arrived in Paris to study in February 1897, shortly after Bay and Rosina. These women were the third generation of artists in a close and warm family that encouraged their artistic ambitions. The Emmets were well connected in society and proud of their famous cousins, William and Henry James, whom Bay had not yet met.[50]

Through an introduction from one of White's partners, Charles McKim, Bay met John Singer Sargent in London. He recognized her talent, saying she had "more … than any man or woman of her age," and encouraged her to paint.[51] Bay, however, arrived in Paris fired with an enthusiasm for study with MacMonnies, which in part had been ignited by the architects McKim and White. In MacMonnies' class at the Académie Vitti, she was overwhelmed by his ability and longed for more intensive and personal instruction. Luckily, her work impressed art critic Paul Bion, a friend of both Saint-Gaudens and MacMonnies, and he passed his opinion on to the latter. MacMonnies "made her come to his studio," her cousin Jane Emmet wrote. "It is a great honor."[52] No doubt influenced by the interdisciplinary methods at the Ecole, MacMonnies took a synthetic approach to artistic training. Bay painted in the morning and modeled in the afternoon, with an aim to improve her drawing.[53] Jane described the spectacle of Bay swearing by plumb lines and measures, going slow, and, on MacMonnies' advice, having "to keep herself and her palette clean and not get wallowing in paint."[54]

After her arrival in Paris in February, Jane Emmet took a class at Colarossi's under Raphael Collin, whom MacMonnies recommended as the best teacher after Falguière. Later that year, she had two "criticisms" from MacMonnies and then raved about him, saying he was a lambent flame of genius, extraordinary, attractive, uncannily clever, and

Figure 7 Frederick William MacMonnies, *Pan of Rohallion*, 1890 (original 1889-90). Bronze, 48 inches high. MacMonnies family papers. Photograph courtesy of E. Adina Gordon

penetrating. (That fall she returned to New York.) Bay, Rosina, and Jane had a fine apartment, a cut above the lifestyle of most art students, and access to the inner circle of artists and architects. The Emmet girls had a great affection for Paul Conkling, whom Bay encountered at MacMonnies' studio. They called him "aunty" Paul, and frequently saw both him and his wife Mabel, an art student who would soon study with MacMonnies. The old-boys network in the artistic world was a tight-knit social club that included students, artists, architects, literati, patrons, and some members of the social elite. Stanford White, visiting Paris in November of 1897, just when Saint-Gaudens was due to arrive to resume residence in France after seventeen years in America, asked MacMonnies to arrange dinner for them all, including the three Emmet girls and the Conklings.[55] The MacMonnieses entertained frequently in Paris and had begun entertaining in Giverny in 1895, when they leased the Villa Bêsche and took up summer residence. From then on, they were established as central figures in the art colony at Giverny.[56]

Posing, Painting, and Portraiture

In mid-May 1897, Bay's first winter of work culminated with the MacMonnieses' invitation to the girls to visit Giverny for the first time and stay at the Villa Bêsche.[57] They were ecstatic and delighted with everything about the village including Monet's garden. An erudite friend of the MacMonnieses, the Curé, L'Abbé Toussaint, came to dinner. Rosina wrote, "[I'll] tell you how life wags on in Giverny: [Robert Chanler], Bay, Mary [Clay][58] and MacMonnies painted me in the old kitchen down by our gate, which they use for a studio. MacMonnies' thing was the best. It is exactly like me. He did me laughing, with my head thrown back, against the old stone chimney. He said he never got a likeness so quickly before."[59] Gratified about Bay's progress in some of the studies she painted in Giverny, MacMonnies said, "If I had her another winter and she improved as she has this, she would paint as well as anyone." Finally, Bay painted her first portrait of MacMonnies, "precisely as if a mixture of Whistler and Sargent had painted him."[60] Developing income from portraiture was important to Bay during her Paris sojourn. In frequent trips to England, she executed commissions obtained through relatives and Sargent. There, she and her sisters met their cousin Henry James for the first time in mid-1897. Of her work, he said, "Bravo MacMonnies."[61]

MacMonnies enjoyed posing and did so for Saint-Gaudens, Falguière, and Whistler. When MacMonnies represented himself as the charging officer in the monumental bronze relief, *Army*, for the *Soldiers' and Sailors' Memorial Arch* in Brooklyn, he also began painting self-portraits in oil.[62] Posing for Bay in Giverny in May of 1897 initiated an artistic activity that intensified through the next four years, resulting in the creation of an interesting group of intimate portraits that MacMonnies and his students painted of each other, as well as his self-portraits.[63]

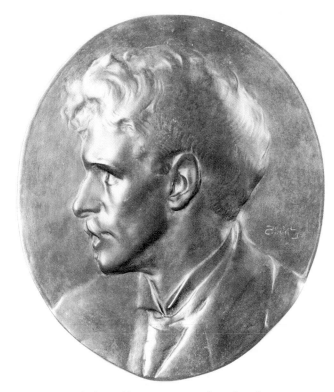

Figure 8 Mabel Conkling, *Portrait of Frederick MacMonnies*, 1937. Bronze, oval relief, 14 5/8 x 12 5/16 x 1 5/16 inches. Bowdoin College Museum of Art, Brunswick, Maine. Museum Purchase, Elizabeth B. G. Hamlin Fund, 1964.046

The sculptors as well as painters used non-commissioned portraiture for expressive means and as tokens of respect; and occasionally they exchanged portraits. Mabel Conkling, whose husband Paul made the turtles for MacMonnies' *Pan of Rohallion* fountain (figure 7), displayed her life-long loyalty to MacMonnies in her memorial bronze portrait medallion, *Portrait of Frederick MacMonnies*, 1937 (figure 8). She also had studied with several French masters, including William-Adolphe Bouguereau at the Académie Julian and Whistler. The body of her work consisted of statuettes, fountains, funerary work, and relief panels. Her realistic, if fleshy, portrait of MacMonnies lacks the energy of line that characterizes MacMonnies' medallic work. The contrary might be said of Helen "Nellie" Mears' *Portrait Relief of Augustus Saint-Gaudens* (figure 9). Mears had studied briefly with Taft and Saint-Gaudens and arrived in Paris in time to gain admission to MacMonnies' over-subscribed class at the Académie Vitti. Exhibiting at the 1897 Salon, she named Félix Charpentier, the French medalist, Collin, Saint-Gaudens, and MacMonnies as her teachers.[64] When Saint-Gaudens arrived six months later, she assisted him in the final reworking of his *Sherman Monument,* 1903 (New York City). A miniature of that equestrian figure is in the background of her large relief plaque, which she made in 1898. In addition to "the portrait [having] the appearance of a quick rough sketch, reminiscent of Charpentier," it displays a dash of MacMonnies' impressionistic handling of clay, with lively surface textures, and realistic appearance.[65]

Shortly after Saint-Gaudens' arrival, Bay, Leslie and Rosina, and their cousin, Jane, heard that Bay's predecessor in the studio, Janet Scudder, whom they had never met, was to return to Paris with their friend Matilda Brownell. They anticipated her arrival with mixed feelings, for MacMonnies, pressed to describe her, had characterized her as "grim" and "like asparagus."[66] Nonetheless, because of their deep attachment to Brownell and their natural, gracious exuberance, Scudder was drawn into their circle, which was energized by the general adulation for MacMonnies. In New York, Scudder had barely eked out an existence doing decorative sculpture and memorial plaques. Through Brownell's father, she had secured a commission for a memorial portrait medallion, which she knew could be made in Paris more inexpensively. His support enabled Matilda to continue her studies and allowed the two women to spend the next three years comfortably situated in an apartment near the Luxembourg Gardens. MacMonnies came in from time to time to visit and gave them informal critiques; Scudder drew from life at Colarossi's and sculpted. Whatever additional work came her way, mostly memorials, did not satisfy her ambition.

In 1899, her first Salon submissions, a plaster bas-relief and the bronze seal, were part of a successful series of portrait medallions that she executed in whisper-low relief, with the beautiful alphabet design from Saint-Gaudens. MacMonnies thought highly of them and, unbeknownst to her, took them to the curator of the Luxembourg Museum.[67] Consequently, the State approved her donation of eight medallions to the museum, and she became the first American woman thus honored by France. Her vibrant portrait

Figure 9 Helen Farnsworth Mears, *Portrait Relief of Augustus Saint-Gaudens,* 1898. Cast bronze, uniface, 8 7/16 x 7 1/4 inches. The American Numismatic Society, New York, 1923.55.1

Figure 10 Janet Scudder, *Leslie Emmet,* 1900. Cast medal, uniface, bronze, 3 1/8 x 2 3/4 inches. The American Numismatic Society, New York, 1912.117.10

relief, *Leslie Emmet*, 1900 (figure 10) made in Paris, was exhibited at the Exposition Universelle in 1900.[68] That same year, Scudder created a portrait of *Alice Jones*, 1900, the woman who would later become MacMonnies' student and second wife (figure 11).

Scudder visited Italy for the first time, traveling with Brownell in the winter of 1899-1900, and found her true path as a sculptor. Inspired by the Renaissance sculpture of Donatello and Verrocchio, and the "gay pagan figures" of Pompeii, she determined to make sculpture for pleasure.[69] A Parisian child-model, hopping and dancing gleefully, helped her bring to life the first of many appealing fountains, *The Frog Fountain,* 1901. She cast it in an edition of four. In MacMonnies' studio, she had learned the value and marketability of his bronze statuettes cast in multiples. "I made it with the intention of having it reproduced just as MacMonnies and Falguière have their statuettes reproduced."[70] Despite the inspiration she found in the Renaissance, her elfin boys and mermaids, whom she called "water babies," relate to the playful, putto-like figure seen in MacMonnies' *Boy and Duck Fountain*. Embellishments of turtles and shells enhance their aquatic themes. With elongated, almost airborne bodies poised on one foot, Scudder's adolescent Pans, lithe girl Victories, and graceful Dianas owe much to MacMonnies' bronzes of the same subjects. MacMonnies encouraged her to take a cast of *The Frog Fountain* to New York, where White saw it in Bay Emmet's studio. He ordered it in marble for the country estate of a client, following the trend for decorating gardens that he had initiated with MacMonnies' *Pan of Rohallion*. Scudder continued to create garden pieces for the great homes of the era with an inventive mind and talented hand.

Female Sculpture Students

The vocabulary of the mentor translated in the hands of his sculpture students like a Romance language: the antecedents remain planted in the student's work. Enid Yandell's mischievous plump Pan, who holds a sprouting branch and stands atop turtles and plant forms on *Hogan's Fountain: Pan (Faune et Tortues),* 1904, is connected to the group of cupids and infant fauns in the fountains MacMonnies produced from 1898 to 1907 (figure 12).[71] Yandell created a cup titled *The Kiss,* 1899, as a wedding gift for her aunt and uncle. She exhibited it at the 1900 Exposition Universelle as *Sirène et Pêcheur* and cited Philip Martiny, MacMonnies, and Auguste Rodin as her teachers.[72] Her relation to the latter is evident in the interlocking form of a kissing mermaid and fisher boy, yet her use of the sinuous *art nouveau* style connects her to MacMonnies. His influence is even more evident in Yandell's *Faune et Tortues* (Salon, 1906), and in her oeuvre of public monuments and fountains, portrait busts, and decorative sculpture.[73]

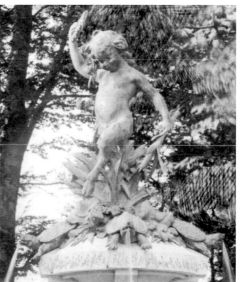

Clio Hinton Huneker, who had been a "white rabbit" with Yandell and Scudder in Chicago, studied with Saint-Gaudens at the Art Students League and attended

MacMonnies' class at the Académie Vitti. While her work also attests to Rodin's influence, she displays an affinity to MacMonnies as a creator of statues for garden settings, many of which were in the *art nouveau* style.

After studies with Saint-Gaudens, Mabel Conyers Herring trained in Paris with Luc-Olivier Merson, Collin, and MacMonnies. She exhibited at the 1899 Salon and the Exposition Universelle in 1900, and later worked in Cornish, New Hampshire, at the studio of Saint-Gaudens.[74]

MacMonnies also inspired another student, Elsie Ward, to go to Paris. While studying with MacMonnies in 1899 she modeled *Boy and Frog,* 1899, a delightful rendering of a nude boy leaning over a ledge and teasing a frog with a stick (figure 13). It won a bronze medal at the 1904 St. Louis Exposition.[75] This playful genre group derives from the slender adolescent or "*corps maigres*" type popular in France in the second half of the nineteenth century and evident in MacMonnies' *Pan of Rohallion.*[76]

MacMonnies' influence can also be perceived in the early work of Edith Burroughs, another of Taft's "white rabbits," who studied briefly with Saint-Gaudens. With Scudder in the "*Atelier des Anges,*" she also attended MacMonnies' class at the Académie Vitti. Her *Circe,* 1907, (figure 14) is a small, sinuous sorceress linked by its mythological theme and twisting form to MacMonnies' famed temptress, the *Bacchante with Infant Faun.* Burroughs' design for *Circe's* elaborate base, decorated with plants and pigs for Circe's magic, is a direct quotation from the ducklings and plants on the base of her mentor's *Boy and Duck Fountain.*[77]

Unlike most of MacMonnies' female sculpture students, Katherine Cohen exhibited at the Salon before she began taking classes with him. Her 1896 Salon entry stylistically paid homage to Saint-Gaudens, Denys Puech (a teacher at the Académie Julian), and MacMonnies.[78] She won honorable mention at the 1900 Exposition Universelle, just after she had returned to her native Philadelphia. Like MacMonnies, Cohen focused on large-scale, ideal sculpture, though she did produce many portrait busts, including a bronze bust of *Abraham Lincoln*, 1898.

Another American student, Carol Brooks, named MacMonnies as her teacher in her Salon debut in 1896. Her work also won honorable mention at the 1900 Exposition Universelle.[79] Brooks' *Chafing Dish*, 1897, supported by three female figures, has a tri-partite base and tri-form dolphins, both of which were favorite motifs of MacMonnies. She designed many such highly stylized functional objects, and small statuettes of the droll, childish, cupid type rendered in the *Boy and Duck Fountain* but without its classical antecedents.

Painting and the Painters: "Académie MacMonnies"

Few of the art students arriving in Paris had the advantage of higher education. Josephine Miles Lewis was a pacesetter as the first woman to receive an undergraduate degree from Yale University and as part of the first graduating class of the Yale School of Fine Arts.[80] She was a pioneer in what would come to be known as the "Académie MacMonnies," as his first student in Giverny beginning in 1895.[81] Lewis lodged for the season at the Hôtel Baudy beginning in April 1895, just at the time the MacMonnieses rented the Villa Bêsche in anticipation of the birth of their first child, Betty.[82] Her last stay at Giverny in April 1897 was just prior to her return to America to continue her career and one month before the Emmet girls first visited the MacMonnieses in the Norman village.[83] At the Salons of 1893 and 1897, Lewis exhibited landscapes, some with figures; the catalogues give no master, but MacMonnies claimed that she and her sister, Matilda, were his students.[84] Another Yale student, Mary Foote, orphaned at thirteen, entered the Yale School of Fine Arts one year before Lewis graduated. In 1897, after seven years superior education, Foote won a two-year travel scholarship, which she stretched to a four-year stay abroad.[85] She went to France with an introduction from New York relatives of the Emmet girls. Grateful to the school and Professor John Ferguson Weir, she wrote periodic progress reports. Colarossi's disappointed her, Collin at the Académie Vitti was a "skilled critic," but she wanted to study with MacMonnies, which was no easy feat to arrange as it was something "so many girls over here are clamoring to do."[86] Yet when she had found her niche with him and was content, she apologized to Weir about the irony of coming "to Paris to study painting under an American sculptor."[87]

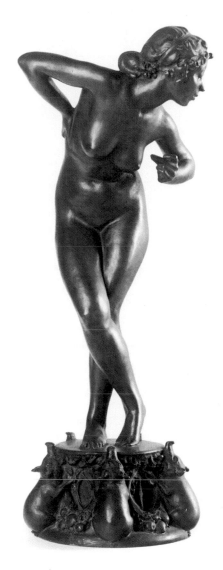

Figure 14 Edith Burroughs, *Circe,* 1907. Bronze, 20 1/2 x 9 1/2 x 4 3/4 inches. The Corcoran Gallery of Art, Washington, D.C. Bequest of James Parmelee, 41.64

Lydia Field Emmet, Jane's sister, arrived two weeks before Foote.[88] She had previously studied in Paris at the Académie Julian for six months in 1885 and in New York at the Art Students League, where her most important teacher was William Merritt Chase. She produced designs and illustrations, a mural for the 1893 Exposition, paintings, and miniatures. Despite Lydia's success as an artist in the States, the letters from Rosina, Jane, and Bay praising the art life in Paris, the pre-modern charm of Giverny, and MacMonnies' teaching had a telling effect.[89] In October 1897, Bay tempted her:

> I think we can concoct enough girls, at just a few to the Patrons [sic] liking, [and] arrange a little studio to get in the Patron perhaps twice a week to wave his wand…. Miss Foote is here snorting fire and holding her breath, with the possible achievement of the…scheme…. I don't want MacMonnies to catch on to the fact that each adjacent bush holds a watchful eye and a hopeful ear…. Short of him it's useless [for you to come].[90]

Lydia came to Paris within six weeks. Living in Montparnasse with her three Emmet cousins, Bay, Rosina, and Leslie, she began taking classes with Collin and MacMonnies.[91] She remained for six months, and during that period, MacMonnies painted a portrait of Lydia at her easel.[92] Given that she was well-trained by Chase, and a more developed artist than Bay or Foote, her artistic gain from her brief half-year sojourn and its connection to MacMonnies warrants consideration. One scholar has suggested that it served to focus her energies in the future on portrait painting.[93] This coincides with MacMonnies' determination that same year to shift gears to painting, in particular, portraiture. White responded to his announcement, "I do not know which to be most glad—that you are going into painting, or sorry that you are going out of sculpture."[94] Lydia Emmet was at her best in her Sargent-like compositions of children. The straightforward, direct pose, serious air, deeper tonalities, and loose brushwork of her adult portraits also show the influence of Sargent and reflect Chase's Munich-based training. (It is noteworthy that MacMonnies also studied painting in Munich.)[95] A fine example of that work is her own *Self-Portrait*, c. 1911, which she gave to the National Academy in 1912 as her diploma presentation piece (figure 15).

Giverny Interlude: Two Disciples

In the summer of 1898, Lydia returned to New York. That year, Bay's mother, Ellen James Temple Hunter, made an extended visit to Giverny from May to September with her son by her second marriage, Grenville Hunter. This half-brother of Bay, who was not yet six, had been her favorite painting subject since his infancy.[96] Mary Foote stayed with Mrs. Hunter that summer. The following summers, until she left for New Haven in August 1901, MacMonnies gave Mary Foote a studio on the grounds at *Le Prieure*. In his house there, he, Mary, and perhaps Bay, ingeniously composed a painting featuring Grenville. The setting is like a shallow stage, with floor that tilts up sharply from front

Figure 15 Lydia Field Emmet, *Self-Portrait*, c. 1911. Oil on canvas, 30 x 24 inches. National Academy of Design, New York

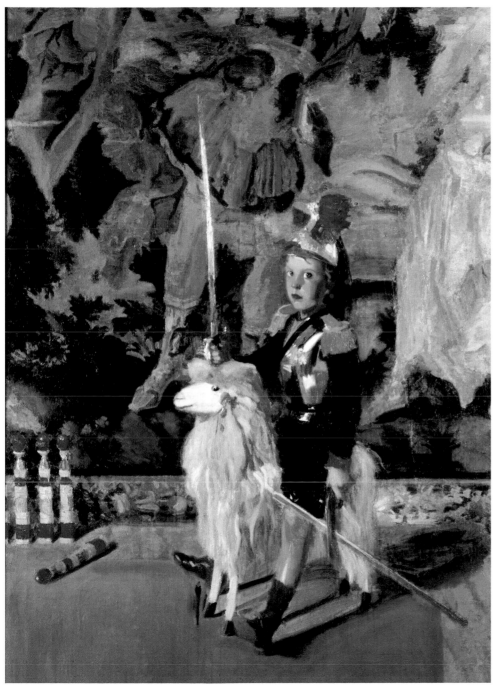

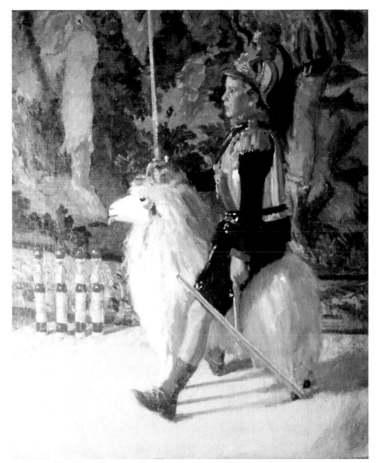

Figure 17 Mary Foote, *Boy in Uniform*, 1898. Oil on canvas. Collection of Julia Moore Converse. Photograph courtesy of Julia Moore Converse

Figure 16 Frederick William MacMonnies, *Portrait of a Boy on a Toy Sheep*, 1898. Oil on canvas, 75 1/4 x 50 1/2 inches. Collection of Donald and Lisa Purdy. Photograph courtesy of E. Adina Gordon

Figure 18 Ellen Emmet Rand, *Landscape*, 1898-1900. Oil on canvas, 15 x 23 1/2 inches. Courtesy of The William Benton Museum of Art, The University of Connecticut, Storrs

to back. One of MacMonnies' antique tapestries hangs as a backdrop—a favorite device of MacMonnies. Helmeted and uniformed, rosy-cheeked Grenville sits on a toy sheep, a sword held upright in one hand and a toy pistol held down at his side in the other. He looks inquiringly at the viewer in MacMonnies' painting, *Portrait of a Boy on a Toy Sheep*, 1898 (figure 16). Foote, standing at a different angle as she painted the scene, represented him in profile in *Boy in Uniform*, 1898 (figure 17). This is the first of several compositions they painted side by side.[97]

Giverny, where plein-air painting was the mode, stimulated and inspired both Bay and Mary. After this idyllic phase of their lives, both students painted mainly portraits for a living, but for that brief interlude in Giverny, Mary painted a series of beautiful, sun-filled scenes of the MacMonnieses' garden. These landscapes are hermetic, many without a single figure, and rendered with flickering brushstrokes and a light impressionist palette. Similarly, Bay painted a village scene devoid of people, clearly the bridge in Giverny and unmistakably by an artist of the colony. *Landscape*, 1898-1900, is one of several canvases that she painted and kept for herself, without ever stretching or exhibiting them (figure 18).[98] Parenthetically, it must be emphasized that landscape proved to be as unusual a genre for Bay in her later work as it was for Matilda Brownell. Brownell's *Spring, Luxembourg Garden*, 1900-02, painted near the apartment Janet Scudder and she shared until 1901, is a rarity in an oeuvre otherwise comprised of portraits, still lifes, figurative paintings, and murals (figure 19).[99]

Figure 19 Matilda Brownell, *Spring, Luxembourg Garden*, 1900-02. Oil on canvas, 11 1/2 x 10 1/2 inches. The Metropolitan Museum of Art. Bequest of Susan Dwight Bliss, 1966

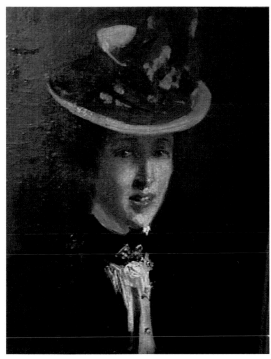

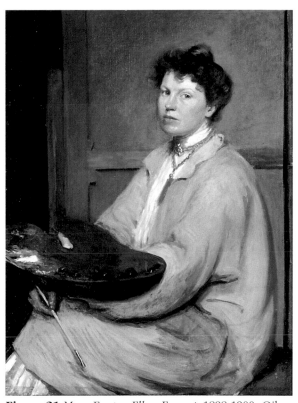

Figure 20 Ellen Emmet Rand, *Mary Foote*, 1898. Oil on canvas. Collection of Christopher S. Foote and Mary Foote Rounsavall. Photograph courtesy of Christopher S. Foote

Figure 21 Mary Foote, *Ellen Emmet*, 1898-1900. Oil on canvas, 40 x 30 inches. Private collection. Photograph courtesy of John Pence Gallery, San Francisco

Both Bay Emmet and Mary Foote, MacMonnies' devoted disciples, painted portraits of him and each other; and he painted informal portraits of them. Bay represented MacMonnies seated at his easel as he painted a portrait of her in *Frederick MacMonnies in His Studio*, c. 1898 (see figure 26).[100] Foote painted the *Portrait of Frederick MacMonnies*, 1898-99, now in the collection of The William Benton Museum of Art, at the same time and in virtually the same pose as Bay's portrait of their mentor, *Frederick MacMonnies*, 1898-99, also now at the Benton. Work and relationships intensified in the winter of 1898-99 when Mary lived with Bay and her sister Rosina. Mary and Bay were infatuated with MacMonnies. They took a studio in Montparnasse, and MacMonnies came to critique their work.[101] Whistler also gave them a few "criticisms." More than a half-century later, when Foote helped to organize a retrospective exhibition of Bay's paintings, she hung two portraits near each other: the portrait of MacMonnies now at the Benton and the unusual portrait Bay had painted of her in Paris, *Mary Foote*, 1898 (figure 20). These paintings represent the close bond of the two women and their teacher in that time and place, as well as Foote's memory of her close personal relations with MacMonnies.[102] Bay's portrait of Mary reveals close connections to Velázquez that might derive from the Spanish master's influence on MacMonnies during his trip to Spain that year. In its bold application of paint and lack of extraneous detail, it is unlike the more highly finished and complex compositions of her mature style in her chosen genre, por-

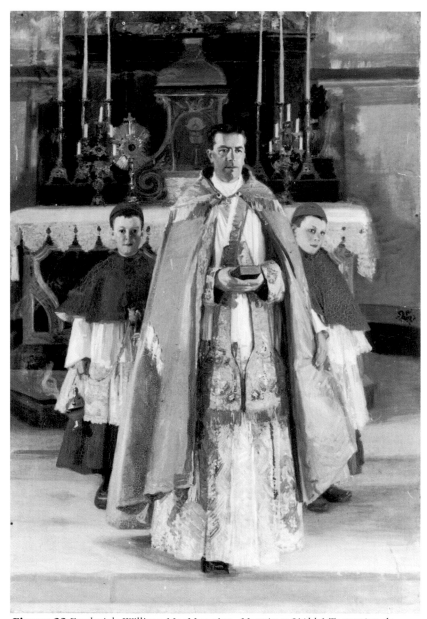

Figure 23 Mary Foote, *The Acolyte*, 1900. Oil on canvas. Collection of Julia Moore Converse. Photo courtesy of Christopher S. Foote

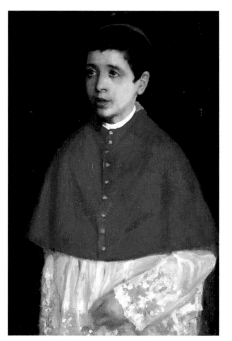

Figure 24 Ellen Emmet Rand, *The Acolyte*, 1900. Oil on canvas, 30 3/8 x 19 5/8. Courtesy of The William Benton Museum of Art, The University of Connecticut, Storrs

Figure 22 Frederick William MacMonnies, *Monsieur L'Abbé Toussaint de Bois-Jêrome*, 1901. Oil on canvas, 88 3/8 x 61 inches. On deposit at the Musée Municipal A.-G. Poulain, Vernon

traiture. Mary's portrait, *Ellen Emmet*, 1898-1900, typifies her early portrait style (figure 21). She shifted to stronger lines and a starker realism in her later work, until she lost control of her artistic identity and stopped painting in the mid-1920s.

In the spring before Bay Emmet returned to pursue her career in America, she and Mary worked side by side with MacMonnies while he made studies for a grand project, the Velázquez-influenced, large-scale composition, *Monsieur L'Abbé Toussaint de Bois-Jérome*, 1901 (figure 22). Toussaint in fact did not pose for this picture, but rather for a bust-length friendship portrait.[103] A local priest in full vestment and two altar boys posed for the full-length sketch of the larger work, probably in the summer of 1900.[104] I believe it was when MacMonnies was occupied with the sketch, that Foote painted her full-length composition, *L'Abbé Toussaint and the Altar Boys*, 1900-1901 (Collection of Julia Moore Converse) and her small canvas, *The Acolyte*, 1900 (figure 23). Bay painted *The Acolyte*, 1900, at the same time using the same model and the same pose (figure 24). The brushwork in Foote's work is characteristically loose, while Bay's painting, like her portrait of *Mary Foote*, is more deliberate and uses greater depth of color. One can surmise that by the time MacMonnies was ready to paint in the faces on his final version the next summer, he substituted a different model for the original altar boy. He signed this work with a small dark Pegasus, the symbol he used on other large-scale works, probably in emulation of or homage to Whistler, who was famous for his butterfly signature.[105]

In Giverny, MacMonnies continued to receive students informally in what had come to be known as the "Académie MacMonnies."[106] Another "young girl student" had arrived in 1900—one of several who pursued MacMonnies (or vice-versa), May Palmer. He painted several portraits of her, and they were lovers.[107] By June, Foote was planning to leave. Leslie wrote, "If you are homesick now at the thought of leaving you will be ten times more so when you get here…Oh, the fickle sense of man and of all human nature. Women can hold their own!!"[108] Her comments allude to the increasingly difficult emotional entanglement between Foote and MacMonnies and his attachments to other women. At this same time, after five years of teaching, MacMonnies organized his thoughts on art, theory, and method with the intention of writing a book. He began by dictating an essay, "The Beautiful Arts of Painting and Sculpture," which contains some thinly veiled personal biographical passages and an apology for his profligacy. Despite all, Mary did not leave until she had organized and edited his notes into a completed handwritten essay.[109]

Painting in America and Giverny, 1902-04; Return to Sculpture: Students and the Last Atelier

In pursuit of portrait commissions, or perhaps Mary Foote, MacMonnies left for the United States in December 1901. (He had completed, but not cast, his equestrian

portrait statue for Brooklyn, *General Henry Warner Slocum,* 1902). Before crossing the Atlantic, he stopped in London to visit his good friend Sargent, who mentored him in portrait painting.[110] Although MacMonnies was well received and successfully produced a number of fine portraits in Philadelphia, Connecticut, and New York, he could not establish the same rapport with Foote that he had had in Giverny. Restless and nervous, he left precipitously for France in November 1902 and did not wait for his first major exhibition of paintings and sculpture that was to be held at the Durand-Ruel Gallery in New York at the beginning of 1903.

MacMonnies' ability as a sculptor was still in demand and, as usual, he was in need of cash earnings. When the commission for another equestrian monument, *Major General George B. McClellan,* 1903-06 (Washington, D.C.), was offered to him at the end of 1903, he accepted. Back at Giverny, his enthusiasm for painting was unabated, and students continued to demand his attention. His first subjects were his daughters. He completed several fine genre compositions of the two of them, and then included them in a multi-figure tondo composition, the ambitious (and previously misdated) *Madonna of Giverny,* 1903 (The Metropolitan Museum of Art).[111] One of the last commissions during his excursion into painting, and before he returned to sculpture, was the portrait of his pupil and friend, *Mabel Conkling,* 1904 (figure 25). It was painted in Giverny in fourteen sittings in July and August of 1904. In compositional form and approach to the subject, it shows close connections to the work of Sargent. This bravura exhibition of quick brushstrokes and vibrant color, typical of MacMonnies' developed portrait style, represents the artist at the peak of his painting career.

Income from portrait commissions, however, slowed to a trickle, and MacMonnies cast about for new ways of generating income. He had a lifetime habit of making small sketches in clay and turned to thoughts of new sculptural projects. At this juncture, one woman insinuated herself into his life. Desirous of becoming his student, Alice Jones negotiated an introduction to MacMonnies through the rigorously principled and never-devious Janet Scudder. Jones' letters document that she was a woman of strong personality and manipulative nature, who enlisted people in high places to promote her plans. She mobilized her well-connected parents, United States senator John P. Jones and Georgina Sullivan Jones, to persuade MacMonnies to accept her as a pupil and into his inner circle at Giverny:

> Write a short note to MacMonnies telling him how much you appreciate his generosity in teaching me, [that it is] a great privilege for me to study under so great a master…Don't…make it too humble…just a friendly note…MacM is just like a child in some ways and has to be managed. He's very sensitive and susceptible to approval. I don't like to lay it on too much myself for fear he will feel 'another adoring pupil' and be afraid I'll fall in love with him. I'm so afraid he may change his mind, or that Janet may influence him. I really must have this chance.[112]

Figure 25 (opposite) Frederick William MacMonnies, *Mabel Conkling,* 1904. Oil on canvas, 86 1/2 x 45 inches. Terra Foundation for the Arts, Daniel J. Terra Collection, 1999.88. Photograph courtesy of Terra Foundation for the Arts, Chicago

Jones began formal study of sculpture with MacMonnies in January 1905, and worked on two of his studies, but made none of her own.[113] She involved herself in developing projects and patrons for him and had her own studio-dwelling in Giverny. MacMonnies' marriage was already in shambles, and their relationship grew more intimate. "After six years under his tutelage," they were married on March 23, 1910.[114]

Between 1905 and 1915, his last decade at Giverny, MacMonnies retained the atelier system and attracted students, competent apprentices, and assistants. In autumn 1905, after study with Taft in Chicago, and the Académie Julian in 1901-02, Sherry Fry wrote to MacMonnies and asked to train under him. MacMonnies responded with an invitation to Giverny, gave Fry one of his three studios, and allowed Fry to work on his project, *Peace Group* or *Pax Victrix,* 1905-07 (The Chrysler Museum, Norfolk, Virginia).[115] Recognizing his talent, MacMonnies encouraged him to do something on his own for the 1906 Salon. When exhibited, Fry's life-size group, *Play*, the first thing he ever tackled alone, won an honorable mention.[116] Fry averred he never did anything himself until MacMonnies passed it.

At age 23, Japanese-born Gozo Kawamura began his assistantship with MacMonnies. He lived in the house of the gardener, Desbois, who had died recently.[117] After working as assistant to Daniel Chester French, Frederic Remington, and others in the United States, Kawamura entered the Ecole.[118] He then applied to MacMonnies and, thereafter, was his factotum for a dozen years. He was a most versatile and devoted assistant and helped in moving Frederick and Alice to the United States just after the outset of World War I. MacMonnies frequently praised his many admirable qualities and talent for sculpture, as well as his unbounded ability as "cabinet-maker, cook…jujitsu athlete, pointer, and modeler.[119]

Conclusion

As one of those talented artists of renown who could draw, paint, sculpt in bronze and in stone, and teach, MacMonnies channeled his energies into making his mark in sculpture. No sooner had he crossed that threshold, than he was besieged repeatedly to share his knowledge in the training of others. His trainees had studied in established teaching institutions and with popular teachers. They came to France where the very environment, which was less restrictive for women, encouraged art and art making. They came for the Academies, the French teachers, and to win honors at the Salons in order to ensure patronage back home. None planned to be permanent expatriates.

The concept of the atelier system predisposed MacMonnies to working with assistants. His ready acceptance of women artists created a new freedom for those he taught. With Scudder he discovered pleasure in teaching and redefined himself as an artist through the need to go back to basics with her: drawing the figure. This brought him again to a

means of artistic expression that he loved, painting. She opened the door for other students. As a talented and popular teacher, he had a quick rapport with them, particularly the women. In fact, MacMonnies focused on the ladies. Although it is true that those men who attended his classes at the Académie Whistler developed their talents and pursued careers as artists, none of those who studied with him privately at his atelier followed that course. Nonetheless, MacMonnies did interact successfully with men. All of those who worked with him as assistants, whether they were skilled artisans or sculptors, Clausade, Grandin, and Tonetti, Fry, and Kawamura, paid tribute to him as their master. The environment of his large active professional atelier, with ideal sculpture groups in progress for patrons and monumental projects for public spaces, energized the ambitions of the young artists. In the classrooms, easy access to live models and his long, personalized critiques of their work fulfilled their expectations in a way that the academies did not.

In Giverny, the MacMonnies home became a perpetual salon with a changing cast of visiting artists and writers to nurture the art students. All were drawn together in creating artistic and social amusements. Freed from the restraints of urban work or study, MacMonnies and his students sketched and painted in walled gardens or in the studio. Painting the same subject together challenged them and became an artistic pastime in this brief interlude in France.

The homage paid to MacMonnies in numerous Salon catalogues is a testament to the loyalty he inspired all of his life from his assistants and students. He painted more than two dozen small sketches and large-scale portraits of them. Many reciprocated by making portraits of him on canvas or in bronze, demonstrating the close bonds that developed between him and those with whom he worked. Great affection is also evident in their portraits of one another, "a genre of non-commissioned portraiture where neither finances nor flattery constrained."[120] From this brief survey of artists connected with MacMonnies, the fact emerges that most of them shared an interest in portraiture as a major vehicle for private expressive means. On the other hand, portraiture functions in an artist's oeuvre as an important generator of income. That was MacMonnies' espoused purpose in switching from sculpture to painting; yet more than half the paintings he produced were portraits of friends and family members, assistants, and students. Of the painters who studied with him, most of the women became portrait painters, whether by design or necessity. Stylistically, in varying degrees, their portraits incorporate elements of the Munich-Velázquez-Sargent-Whistler base that informs MacMonnies' painting.

The stock-in-trade of most of his sculpture students were fountains for public spaces, garden sculpture and fountains, small-scale ideal statues, portrait busts and reliefs, architectural sculpture, relief panels, cemetery urns, and functional objects for the home. Based on mythological, classical, symbolist, and art nouveau themes, his students' work carried forward styles that frequently derived from MacMonnies' seminal works of the

1890s. His students also benefited from his pioneering example of creating a lucrative production of fine quality "parlor bronzes," which were reductions of his most popular large-scale works. His successful marketing of the bronzes in America paved the way for that younger generation of artists to support itself through sales of works in multiples.

The expansion of MacMonnies' career from sculptor to teacher to painter was not a seamless continuum. MacMonnies' new role of master was far greater than has previously been understood, for he was unique among American artists working in the quarter-century preceding World War I for the number of students he attracted in both Paris and Giverny. (Those who have been identified thus far are listed below). His involvement with teaching also demonstrates that the artist painted for ten years, hardly the "brief" sabbatical suggested by the literature. Teaching and painting became part of MacMonnies' life as an artist due to his indefatigable artistic energy and to an engaging personality that ultimately drew numerous assistants and students to him.

A List of Known Students of MacMonnies

Abbot, Katherine Gilbert, later Mrs. Allen Howard Cox (1867-1929)

Bennet, Helen

Brooks, Carol, later Mrs. Hermon A. MacNeil (1871-1944)

Brownell, Matilda Auchincloss (1871-1966)

Burroughs, Edith Woodman (Mrs. Bryson Burroughs) (1871-1916)

Clausade, Louis (1856-1899)

Clay, Mary, later Mrs. A.C. Ewart, (d. 1939)

Cohen, Katherine A. (1869-1914)

Conkling, David Paul Burleigh (1871-1926)

Conkling, Mabel Viola Harris (Mrs. David Paul Burleigh Conkling) (1871-1966)

Emmet, Edith Leslie (b. 1877)

Emmet, Ellen "Bay" Gertrude, later Mrs. William Blanchard Rand (1875-1941)

Emmet, Jane Erin, later Mrs. Wilfrid De Glehn (1873-1961)

Emmet, Lydia Field (1866-1952)

Farley, Richard Blossom (1875-1954)

Flanagan, John (1865-1952)

Foote, Mary Hubbard (1872-1968)

Fry, Sherry Edmundson (1879-1966)

Grandin, Léon (1856-1901)

Herring, Mabel Conyers

Herter, Adele McGinnis (Mrs. Albert Herter) (1869-1946)

Herter, Albert (1871-1950)

Hinton Huneker, Clio, later Mrs. William B. Bracken (1870-1925)

Jones, Alice, later Mrs. Frederick William MacMonnies (1876-1963)

Kawamura, Gozo (1886-1950)

Lewis, Josephine Miles (1865-1959)

Mears, Helen Farnsworth (1871-1916)

Palmer, May Suydam (1870-1941)

Roudebush, John Heywood (1870-1925)

Scudder, Janet (1869-1940)

Slade, Conrad

Taft, Zulime, later Mrs. Hamlin Garland

Tonetti, François-Michel-Louis (1863-1920)

Trowbridge, Lucy Parkman

Ward, Elsie, later Mrs. Henry Hering (1872-1923)

Yandell, Enid (1870-1934)

Zucker, Harry

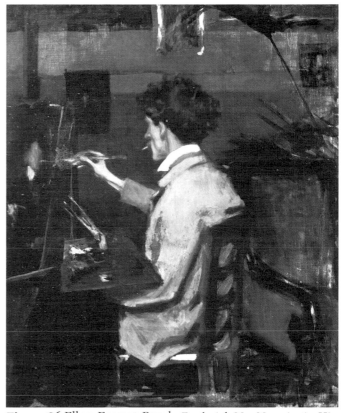

Figure 26 Ellen Emmet Rand, *Frederick MacMonnies in His Studio*, c. 1898. Oil on canvas, 21 3/8 x 17 1/2 inches. Courtesy of The William Benton Museum of Art, The University of Connecticut, Storrs

Notes

1 See Ethelyn Adina Gordon, "The Sculpture of Frederick William MacMonnies: A Critical Catalogue," Ph.D. diss., Institute of Fine Arts, New York University, 1998, cat. no. 29.

2 In his waning years, MacMonnies provided an interviewer with the names of fourteen students that he remembered: "Hilda Bennet, Paul Conkling, Bay Emmet, Miss Mary Foote, Sherry Fry, Gozo Kawamura, Misses Matilda and Josephine Lewis, Janet Scudder, John H. Roudebush, Miss Enid Yandell, Harry Zucker, Albert Herter, Mr. and Mrs., were there (in my class in the Whistler Academy)." "Interviews with Frederick MacMonnies, N.A.," II, February 15, 1927, *DeWitt Lockman Collection of Interviews with American Artists in the New-York Historical Society*, Archives of American Art, Smithsonian Institution, Washington, D.C., microfilm reel 503; fr. 945. I have found no other trace of Bennet and Zucker.

3 Lorado Taft, *The History of American Sculpture* (New York: Macmillan, 1903; revised with supplemental chapter, 1923; new edition with supplemental chapter by Adeline Adams, 1930), 332.

4 Adeline Adams declared MacMonnies' ascendancy in creating the genre of garden fountain sculpture in *The Spirit of American Sculpture* (New York: National Sculpture Society, 1923), 163. Michelle H. Bogart reiterated and elaborated on this point in, "American Garden Sculpture: A New Perspective," in *Fauns and Fountains: American Garden Statuary, 1890-1930* (Southampton, N.Y.: The Parrish Art Museum, 1985), n.p.

5 The record of this period, when MacMonnies taught and made most of his paintings, is rife with flirtations and indiscretions with his students, as well as several love affairs. He had a long-term relationship (1895 to 1899) with Helen Gordon Glenn, with whom he had a son, Robertson Ward, whom he never recognized. Ward was born in France in 1897, within weeks of the birth of his second child by Mary Fairchild MacMonnies, Marjorie. I interviewed Ward in London when he was 90 years old and had had a successful career as an architect. See Ethelyn Adina Gordon, with *Avant Propos* and catalogue notes by Sophie Fourny-Dargère, *Frederick William MacMonnies et Mary Fairchild MacMonnies: deux artistes américains à Giverny*, exh. cat. (Vernon: Musée Municipal A.-G. Poulain, 1988), 25 and 73 n. 21. The affair is discussed in detail in Mary Smart, *A Flight with Fame: The Life and Art of Frederick MacMonnies*, with a Catalogue Raisonné of Sculpture and a Checklist of Paintings, by E. Adina Gordon (Madison, Conn.: Sound View Press, 1996).

6 H. W. Janson in Robert Rosenblum and H. W. Janson, *Nineteenth Century Art* (New York: Harry N. Abrams, 1984), 502.

7 See Gordon, "The Sculpture of Frederick William MacMonnies: A Critical Catalogue," cat. nos. 24, 25.

8 Clausade and his wife, Pauline, were friends and neighbors at the impasse du Maine, the setting for Mary MacMonnies' large Salon painting of herself and Pauline, *Between Neighbors (Entre Voisines)*, 1891 (Sheldon Swope Art Museum, Terre Haute, Indiana). The Clausades also visited the MacMonnieses when they resided in Giverny. Art critic Paul Laurent Bion, Saint-Gaudens' lifelong friend and ardent correspondent, and MacMonnies' champion, described Grandin as *"le chef d'atelier de la fontaine"* (letter from Bion to Saint-Gaudens, July 28, 1893), Augustus Saint-Gaudens Archives, Dartmouth College Archives and Special Collections, Baker Library, Hanover, New Hampshire.

9 For example, Salon 1898, "Léon Grandin, élève de Millet, de Gauthier, de MM MacMonnies et Falguière. S. *347 -un vieux loup de mer;* buste plâtre." (*Explication des ouvrages de peintures, sculptures, des artistes vivants* [Paris: 1ˢᵗ ed. Impr. Paul Dupont], 1898), 354 [titles vary slightly by years]; and "Salon 1895, Tonetti (François-Michel-Louis),... élève de MM Falguière, Tony Noel, MacMonnies et Doublemard....3536 - *Irène* – statue plâtre," (*Explication*, 1895). MacMonnies' name appeared in Tonetti's Salon entries until 1902. Grandin frequently visited the MacMonnieses at Giverny.

10 They drifted apart after Tonetti's marriage to Saint-Gaudens' student and assistant, Mary Lawrence, in 1900. She is misidentified as MacMonnies' assistant in Charlotte Streifer Rubinstein, *American Women Sculptors* (Boston: G. K. Hall, 1990), 130. Lawrence was Saint-Gaudens' student and assistant until she left for Paris in December 1893 and established a studio next to MacMonnies in the impasse du Maine, which is how she met Tonetti. See letter from Bion to Saint-Gaudens, January 15, 1894, Saint-Gaudens Archives.

11 See Gordon, "The Sculpture of Frederick William MacMonnies: A Critical Catalogue," cat. no. 48.

12 See Gordon, "The Sculpture of Frederick William MacMonnies: A Critical Catalogue," cat. no. 74, *Boy on Goose*.

13 For a discussion of Saint-Gaudens' students and apprentices who were so influenced see E. Adina Gordon, "Augustus Saint-Gaudens: The Lure of Paris," in *Augustus Saint-Gaudens 1848-1907: A Master of American Sculpture*, exh. cat. (Toulouse: Musée des Augustins, 1999), 92-93.

14 The dating is based on Helen Anne Hilker, "A Monument to Civilization: The Diary of a

Building," *Quarterly Journal of the Library of Congress* 29 (October 1972): 256-57.

[15] See E. Adina Gordon, "The Paintings of Frederick William MacMonnies: A Checklist," in Smart, *Flight With Fame*, no. 34.

[16] John Flanagan, *F. W. MacMonnies*, 1929, bronze (The Newark Museum), acc. no. 29.801.

[17] See Antoinette le Normand-Romain in Pingeot, et. al., *La Sculpture Française dans la XIXth Siècle*, exh. cat. (Paris: Editions de la Réunion des musées nationaux, 1986), 31.

[18] See letter from Mary Foote to Professor John Ferguson Weir, November 24, 1897, Mary Foote Papers, Beinecke Rare Book and Manuscript Library, Yale University.

[19] Born Netta Deweze Frazee in 1869, she changed her name. (1873 is frequently cited as Scudder's birth date). For a discussion of this subject and an excellent overview of Scudder's career, see Janis Conner and Joel Rosenkranz, *Rediscoveries from American Sculpture: Studio Works, 1893-1939* (Austin: University of Texas Press), 151.

[20] Strained financial circumstances would continue to plague her during her student days in Paris and her first sojourn in New York as a young sculptor from 1894 to 1898.

[21] See Janet Scudder, *Modeling My Life* (New York: Harcourt, Brace, 1925), 57 ff. Scudder is vague about dates throughout her memoir. MacMonnies' *Columbian Fountain*, shipped full-sized from Paris, required only on-site assembly.

[22] Scudder also named Lorado's sister, Zulime, and Bessie Potter, later Mrs. Robert Vonnoh.

[23] Scudder, 63.

[24] Scudder, 80, 152.

[25] Scudder, 85.

[26] Burroughs is not recognized in the literature as one of MacMonnies' students. For example,

see Peter Hastings Falk, ed., *Who Was Who in American Art 1564-1975: 400 Years of Artists in America* (Madison, Conn.: Sound View Press, 1999), 517, Taft, 542, and Rubenstein, 236 ff. See Salon 1894. "Mlle. Katherine Gilbert Abbot, née à Gainesville, Ohio (no master given). P - 2. *Portrait de M. K*"; and Salon 1895, SNBA, "P. 1. *Portrait de Mlle.. Y... P. 2 Anxiété*" (*Explication*). "[There were] four girls whose drawings he used to correct when few had that privilege.... Miss Scudder, Miss Taft, and Miss Yandell. The fourth was young Mrs. Burroughs, wife of the brilliant student who won the Chanler scholarship-five years of study in Europe" (*Chicago Evening Post*, August 8, 1896), in "Frederick W. MacMonnies, Scrapbooks (5) of newspaper clippings, 1889-1908," Archives of American, reel D245; fr. 111.

[27] Letter from Brownell to Lydia Emmet, May 4, 1894, Emmet family papers, Archives of American, reel 4755; fr. 856-61.

[28] The painter Lucy Parkman Trowbridge is reported to have been in this class.

[29] For the engraving, see "Class Taught by F. W. MacMonnies-Académie Vitti," *Chicago Evening Post*, reel D245; fr. 111. See "MacMonnies Criticizing the Work of American Students," (original photograph), in Scudder, facing 86.

[30] Letter from MacMonnies to White, January 10, 1892, McKim, Mead & White\Frederick MacMonnies Correspondence. MacMonnies family papers, photocopies, E. Adina Gordon.

[31] The final work was canceled. One of the panels painted in 1895-96 was at the house in Giverny in 1927. See Gordon, "Checklist of Paintings," no. 5.

[32] E. R. and J. Pennell, *The Life of James McNeill Whistler*, vol. II (Philadelphia: J. B. Lippincott Co., 1911), 239.

[33] Letter from Farley to Cecilia Beaux, November 1, 1898, Cecilia Beaux Papers 1863-1968, Archives of American, reel 3134; fr. 1571.

[34] For MacMonnies' mention of the Herters, see Lockman, "Interviews," II, 503; 945. The Herters were active in the Arts and Crafts movement in America, designing and looming tapestries.

[35] See Gordon, "The Sculpture of Frederick William MacMonnies: A Critical Catalogue," cat. no. 42.

[36] See Gordon, "The Sculpture of Frederick William MacMonnies: A Critical Catalogue," cat. no. 43. Scudder worked on the *Shakespeare* cloak for three months. For *Victory,* see Gordon, "The Sculpture of Frederick William MacMonnies: A Critical Catalogue," cat. no. 38 and 256 n. 5. For *Bacchante,* see Gordon, "The Sculpture of Frederick William MacMonnies: A Critical Catalogue," no. 30 and 190 n. 16, describing Scudder's work with Vaseline on an unsuccessful lost wax cast.

[37] See Gordon, "The Sculpture of Frederick William MacMonnies: A Critical Catalogue," cat. no. 50 and 351 n. 5.

[38] Scudder, 105.

[39] Letter from Saint-Gaudens to MacMonnies, June 29, 1896, Saint-Gaudens\MacMonnies Correspondence, 1884-1907, Archives of American, reel 3042; fr. 265.

[40] Letter from White to MacMonnies, August 1, 1896, and letter from MacMonnies to White, November 16, 1896. McKim, Mead correspondence.

[41] Scudder presented the original statuette to the President and helped to market the remaining casts. See Gordon, "The Sculpture of Frederick William MacMonnies: A Critical Catalogue," cat. no. 65.

[42] Ellen Gertrude Emmet, known as "Bay," noted that these three men were working in the atelier when she arrived there to commence her studies with MacMonnies. See letter from Bay to

Jane, December 1896, typescript, Emmet family, reel 4755; fr. 934.

[43] "Town Topics," *New York Times,* November 13, 1898, reported that Slade's engagement was announced in Boston, that he was a Harvard '93 man, and was working under MacMonnies in Paris (clipping in Scrapbooks, 30).

[44] See obituaries, *New York Times, Tribune* and *Sun,* all April 24, 1925 (clippings, MacMonnies family papers).

[45] See Salon 1898, "S. - 3823. *Boxeurs*: -groupe, plâtre" (*Explications*).

[46] See "Rondebust [sic] J.H., - New York, N.Y. *Les Lutteurs*," (*Exposition Universelle de 1900: Catalogue Général officiel, 2 Groupe II- Oeuvres d'art,* [Paris: Lemercier, 1900]), 59. The same sculpture group won a silver medal the following year in Buffalo. See "J. H. Roudebush: 1645. *The Wrestlers*" (*Catalogue of the Exhibition of Fine Arts. Pan American Exposition, Buffalo, 1901* [Buffalo: David Gray, 1901]), 71. Taft, *History,* 448, mentions these prizes without further elaboration.

[47] For all three portraits, see Gordon, "Checklist of Paintings," nos. 35, 93, and 105.

[48] See Gordon, "The Sculpture of Frederick William MacMonnies: A Critical Catalogue," cat. no. 48 and 337 n. 33.

[49] See letter from Bay to Jane, December 1896, typescript, Emmet family, reel 4755; fr. 934.

[50] For chronology of events in the lives of Lydia and Ellen, and essays about their lives and work, see Tara Leigh Tappert, *The Emmets: A Generation of Gifted Women,* exh. cat. (New York: Borghi, 1993).

[51] Letter from Jane to Lydia, February 1897, Emmet family, reel 4755; fr. 949.

[52] Letter from Jane to Lydia, February 1897, Emmet family, reel 4755; fr. 949.

[53] Letter from Jane to Lydia and her brother Arthur, February 4, 1897, Emmet family, reel 4755; fr. 961.

[54] Letter from Jane to Lydia, spring 1897, Emmet family, reel 4755; fr. 1065.

[55] See letter from White, Hôtel Vêndome, Paris, to MacMonnies, n. d., dated from the context, first week of November 1897, McKim, Mead correspondence, letter no. 51.

[56] See David Sellin, *Americans in Brittany and Normandy 1860-1910,* exh. cat. (Phoenix: Phoenix Art Museum, 1982), 76-77.

[57] See letter from Jane to Julia, May 20, 1897, Emmet family, reel 4755; fr. 1096.

[58] Jane Emmet and Rosina Hubley Emmet mentioned Mary Clay in several of their letters. Clay studied with MacMonnies at the Académie Vitti, with Collin, and with Chase in New York. See Falk, 662.

[59] Letter from Rosina to Lydia, n.d. [1897], Emmet family, reel 4755; fr. 1017.

[60] Letter from Jane to Lydia, May 4, 1897, Emmet family, reel 4755; fr. 1100-1103.

[61] Quoted in Hildegard Cummings, *Good Company,* exh. cat. (Storrs, Conn.: The William Benton Museum of Art, 1984), 7. This is an insightful and informative essay on Ellen Emmet Rand and her work.

[62] For *Army,* self-portraits, and posing for other artists, see Gordon, "The Sculpture of Frederick William MacMonnies: A Critical Catalogue," cat. no. 55. For self-portraits see Gordon, "Checklist of Paintings," nos. 60-69.

[63] See letter from Jane to her mother, Julia Colt, May 24, 1897, Emmet family.

[64] See Salon 1897, Mears, Mlle. Nellie Farnsworth…élève de Charpentier, R. Collin, Augustin, Saint-Gaudens et Mac-Monnies. S-

3195. *Portrait de M.D. - buste, plâtre.*" (*Explication*, 1898), quoted in Lois Marie Fink, *American Art at the Nineteenth-Century Paris Salons* (Washington, D.C.: National Museum of American Art, Smithsonian Institution, 1990), 371.

[65] Elaine J. Leotti, "The American Woman Medalist," in Alan M. Stahl, ed., *The Medal in America* (New York: The American Numismatic Society, 1988), 205.

[66] See letters from Jane to Lydia, c. March 1897, and spring 1897, Emmet family, reel 4755; fr. 1030 and 1065. "The grim Scudder does not seem to be much beloved here. I can't make out whether MacMonnies liked her or not" (letter from Jane to Lydia, April 16, 1897), reel 4755; fr. 1074.

[67] One of her finest portrait reliefs, *Matilda Brownell,* c. 1901 (private collection), is a friendship painting in bronze.

[68] "Scudder (Mlle. Janet)… élève de M. Frederic Mac-Monnies…. 2137 – *Portrait de Mlle. Emmet*; medallion, marbre et bronze" (*Exposition Universelle*), 281.

[69] Scudder, 165.

[70] Letter from Scudder to White, November 17, 1905, [SW 15:2]. Stanford White Papers, Avery Architectural Library, Columbia University.

[71] See Gordon, "The Sculpture of Frederick William MacMonnies: A Critical Catalogue," cat. nos. 48, 66, 68, and 77.

[72] Yandell's aunt, Elsie Trask (Mrs. John H., Jr.) told me about the wedding gift in an interview, October 8, 1986. See "Yandell (Enid)… 70. – *Sirène et garcon pêcheur*." (*Exposition Universelle*), 388.

[73] See Salon 1906, Yandell, E…. élève de MM. Rodin et MacMonnies…S –3620 –*Faune et tortues;* fontaine, plâtre, (*Explication*), 318.

[74] See "Mrs. Herring, a pupil of Saint-Gaudens and MacMonnies," *New York Tribune*, March 4, 1900" (Scrapbooks, reel D245; fr. 41); and "Conyers-Herring, Mme. Mabel...1899, SNBA, S- 32- *Portrait de M. C.* - statuette en plâtre," *(Explication)*, quoted in Fink; and "Herring (Mlle. Mabel C.), née à Boothbay, Maine, élève de Merson, Collin, St. Gaudens et MacMonnies. Paris. 32. *Echo*" (*Exposition Universelle*), 387.

[75] See Rubenstein, 135.

[76] Ward returned to America with Saint-Gaudens and helped finish some of his work after his death. She married another assistant, Henry Herring, in 1910. See Gordon, "Lure," 93, and Rubenstein, 135.

[77] The Corcoran *Circe*, one of several known casts, entered the collection in the same bequest of James Parmelee, 1941, as MacMonnies' *Dancing Woman*, 1898-1905, a figurine with a large, biomorphically decorated base. See Gordon, "The Sculpture of Frederick William MacMonnies: A Critical Catalogue," cat. no. 67, with a discussion of the connection between Parmelee and two of MacMonnies' paintings.

[78] Cohen previously exhibited in 1892 and 1893. 1896 was the last time she exhibited at the Salon. For her Salon exhibition history, see Fink, 331. Cohen returned to Philadelphia in 1899.

[79] "Salon 1899. Brooks (no first name given), élève de M. MacMonez [*sic*], S- 3274. *Vierge folle*" (Fink), 325. See "MacNeil (Carol-Brooks), né à Chicago, Ill., élève de Loredo Taft, Mac Monnies et Injalbert. –à Paris. 42.- *Support de fiasco*. 43. –*Samovar*. 44. –*Giotto jeune*." (*Exposition Universelle*), 387.

[80] For an important study of this school, see Betsy Fahlman, "Women Art Students at Yale, 1869-1913," *Woman's Art Journal* 12 (Spring/Summer 1991): 15-23; for Lewis, see 18. Her professors were Weir and John Henry Niemeyer.

[81] Traditional belief has it that it was in 1894, during the second of her long painting holidays there; but MacMonnies was not in Giverny that year. He first taught to a wider group (including Lewis) in 1895 and recollected teaching both Josephine and her sister, Matilda (for whom there is currently no record as an artist).

[82] See registration at the Hôtel Baudy, for Josephine in March, April-July, and October-November, 1894, nos. 352, 368, and 404; in April 1895, no. 421; for Josephine and her sister, Matilda, in June 1896, nos. 515 and 516; and in April 1897, nos. 556, 557, *Régistre pour inscrire les voyageurs, June 30, 1887-August 9, 1899*, Hôtel Baudy, Giverny, France (Library, Philadelphia Museum of Art).

[83] "During the warm months...MacMonnies took his Parisian students to Giverny. Lewis studied with him during the summer of 1894." (Betsy Fahlman, "From Connecticut to France: New Haven Painters in Paris, Barbizon, Brittany, and Giverny," *Journal of the New Haven Colony Historical Society* (Fall 1994): 51. Recent scholarship shows that it is unlikely that MacMonnies started to teach at Giverny in 1894, or that he had a school in Giverny that year, as Fahlman states in "Women Art Students," 18.

[84] See n. 2.

[85] The scholarship was the first William Wirt Winchester Prize.

[86] Letter from Foote to Weir, November 24, 1897, Foote Family.

[87] Letter from Foote to Weir, May 13, 1899, Foote Family.

[88] Many letters in the Emmet family papers are undated and cause some confusion for scholars. William H. Gerdts, in *Monet's Giverny: An Impressionist Colony* (New York: Abbeville Press, 1993), states that Bay, Leslie, and Lydia all studied "at the Académie Vitti the year before [their

stay] at the villa in the spring of 1897." This means 1896, which is incorrect for Lydia. Neither she nor Leslie was in France in 1896. Gerdts also states, "he offered criticism to these artists in 1899, as he was turning to painting," 142. As demonstrated herein, MacMonnies offered criticisms in Giverny in May 1897 and all of the following summer, and was painting from 1896 to 1899.

[89] See letter from Rosina to Lydia, Spring 1897, Emmet family, reel 4755; fr. 1016-1020 (incorrectly dated 1898 in printed synopsis of the letters on file at Archives of American Art offices).

[90] Letter from Bay to Lydia, October 13, 1897, Foote family files.

[91] For a review of Lydia Emmet's career, except for this period in Paris, see Martha Hoppin, *The Emmets: A Family of Women Painters*, exh. cat. (Pittsfield, Mass.: Berkshire Museum, 1992).

[92] See Frederick MacMonnies, *Smiling Artist at Her Easel*, 1898-99 (location unknown), in Gordon, "Checklist of Paintings," no. 13.

[93] See Tappert, 24.

[94] Letter from White to MacMonnies, November 22, 1898, McKim, Mead correspondence.

[95] Robert Judson Clark in "Frederick MacMonnies and the Princeton Battle Monument," *Record of The Art Museum,* Princeton University, 43 (1984): 6, remarks that MacMonnies' "studies of friends and local types have a look of German Impressionism, as though they might have been done in Munich." See my discussion of these and other Giverny paintings in Gordon, *Frederick William MacMonnies et Mary Fairchild MacMonnies,* 53-54.

[96] See letters from Lydia to Julia, March 11, 1898; Lydia to Jane, April 12, 1898; and Lydia to Julia, May 6, 1898; all Emmet family.

[97] I identified three pairs of compositions that they painted side-by-side in Gordon, *Frederick*

William MacMonnies et Mary Fairchild MacMonnies, 53, 79 n. 93. It is clear now that Ellen Emmet Rand worked with them on studies for at least one composition, *L'Abbé Toussaint*.

[98] The William Benton Museum of Art received this painting and several others from the family, unstretched, and with no background information.

[99] The Department of American Painting and Sculpture at The Metropolitan Museum of Art assigns a tentative date of 1902 to this painting based on the incorrect assumption that Brownell returned to Paris in 1902. The painting remained in possession of the artist until she died. She and the Emmets and Mary Foote retained the portraits of each other and landscapes of their surroundings made in that period for their own pleasure. MacMonnies made an oval relief portrait of Brownell's younger sister, Eleanor O. Brownell (1876-1968), in 1936. See Gordon, "The Sculpture of Frederick William MacMonnies: A Critical Catalogue," cat. no. 113.

[100] See Frederick MacMonnies, *Ellen Emmet in Her Studio*, 1897-99 (The William Benton Museum); *Portrait of Ellen Emmet at Her Easel*, 1898-99 (private collection); and *Half-length Portrait of a Nude Woman*, 1899-1902 (private collection); in Gordon, "Checklist of Paintings," nos. 11, 12, and 39.

[101] Smart states that this studio was at MacMonnies' rue de l'Arrivée studio (which is not indicated in the correspondence) and that Brownell was the massière of Académie MacMonnies. Smart also quotes accounts kept by Brownell dated February-March 1901 for "Académie MacMonnies" at the house in Giverny. See Smart, *Flight with Fame*, 200, and 212 n. 3. This would post-date the Emmets' sojourn in France.

[102] See *Paintings by Ellen Emmet Rand* (Pittsfield, Mass.: Berkshire Museum, 1954).

[103] For *L'Abbé Toussaint*, full-length sketch (private collection, France); and bust portrait, *Portrait L'Abbé Toussaint*, oil on canvas (Sacristy, Church of Montaure, France), see Gordon, "Checklist of Paintings," nos. 31 and 33.

[104] According to Fourny-Dargère, Toussaint would not have donned the vestments to pose for an "official" portrait that was not commissioned by the church.

[105] This observation was made by the author in Gordon, *Frederick William MacMonnies et Mary Fairchild MacMonnies*, 55.

[106] As yet there is no complete record of those who attended.

[107] See Will H. Low, "In an Old French Garden," *Scribner's Magazine* 32 (July 1902): 3-16, for a description of the garden, the artists, and "studentesses." For Palmer, see letter from MacMonnies to Foote, September 3, 1900, Foote Family. "She had a long affair with MacMonnies at Giverny." Falk, ed., *Who Was Who*, 2512. For MacMonnies' portraits of May Suydam Palmer, see Gordon, "Checklist of Paintings," nos. 37, 38, 73, and 76.

[108] Letter from Leslie Emmet to Foote, forwarded to Giverny, June 20, 1901, Foote Family.

[109] See Frederick MacMonnies, "The Beautiful Arts of Painting and Sculpture," Foote Papers.

[110] See letter from MacMonnies to "Louie" [Mary MacMonnies], December 1901 [firmly dated from context], MacMonnies family papers, E. Adina Gordon, on deposit. MacMonnies was on his way to New York to paint portraits.

[111] See Gordon, "Checklist of Paintings," no. 77. This publication did not publish the correct date for the painting that I supplied based on a letter from Mary MacMonnies to Anne Archbold, December 19, 1903, stating, "Max has painted a Virgin Child with four angels–such a beautiful picture" (John Archbold Collection).

[112] Alice Jones to Georgina Sullivan Jones, December 11, 1904, Box 29, John Percival Jones Papers, on deposit, Henry E. Huntington Library, San Marino California. See also Gordon, "The Sculpture of Frederick William MacMonnies: A Critical Catalogue," cat. no. 69.

[113] See letter from MacMonnies to Georgina, February 23, 1905, Jones Papers. For studies, see Gordon, "The Sculpture of Frederick William MacMonnies: A Critical Catalogue," cat. nos. 69, 72, and 98.

[114] "MacMonnies-Jones Wedding [in] the Cards Soon," *New York World*, January 25, 1910, 1.

[115] See "Interviews and Biographical Sketches: Sherry Fry, First Interview," Lockman, Archives of American Art, reel 503; fr. 249.

[116] See "Sherry Fry, First Interview," reel 503; fr. 250.

[117] See *The Poacher: Desbois and the Game* in Gordon, "Checklist of Paintings," no. 78.

[118] See Michael Richman, *Daniel Chester French: American Sculptor*, exh. cat. (New York: The Metropolitan Museum of Art, 1976), 28, and *Exhibition of American Sculpture*, exh. cat. (New York: National Sculpture Society, 1923), 126.

[119] Letter from MacMonnies to Betty and Marjorie, December 12, 1910, MacMonnies family papers.

[120] *Modern Portraits: The Self and Others*, exh. cat. (New York: Wildenstein, 1976), Foreward, xi.

An Interlude in Giverny: The French Chevalier *by Frederick MacMonnies*

Checklist

Frederick William MacMonnies
Bacchante with Infant Faun, 1894
Bronze with dark green patina
34 3/4 x 11 1/2 x 11 1/2 inches
Terra Foundation for the Arts,
Daniel J. Terra Collection, 1988.20

Frederick William MacMonnies
Diana, 1894
Bronze with golden patina
30 1/2 x 20 1/2 x 16 1/4 inches
Terra Foundation for the Arts,
Daniel J. Terra Collection, 1988.21

Frederick William MacMonnies
Cupid, 1898
Ivory, hammered gold, lapus lazuli,
marble, mahogany, bronze
16 inches high (including base)
Private collection

Frederick William MacMonnies
Berthe with Doll Amelia, 1898-99
Oil on canvas on masonite
23 1/4 x 19 1/4 inches
The Schwarz Gallery, Philadelphia

Frederick William MacMonnies
Monsieur Cardin, 1900-01
Oil on canvas
70 3/4 x 41 3/4 inches
Berry-Hill Galleries, New York

Frederick William MacMonnies
The French Chevalier, 1901
Oil on canvas
89 x 50 1/2 inches
Palmer Museum of Art
Gift of Mr. and Mrs. Melvin S. Frank

Frederick William MacMonnies
*Mrs. Frederick MacMonnies and Children
in the Garden of Giverny,* 1901
Oil on canvas
25 x 21 inches
Private collection

Frederick William MacMonnies
Self-Portrait, c. 1904
Oil on canvas
31 x 25 inches
The Metropolitan Museum of Art
Gift of Mrs. James W. Fosburgh, 1967

Mary Fairchild MacMonnies
C'est la fête à bébé, c. 1896-98
Oil on canvas
15 1/8 x 18 1/4 inches
Terra Foundation for the Arts,
Daniel J. Terra Collection, 1999.90

Mary Fairchild MacMonnies
Dans la nursery, c. 1896-98
Oil on canvas
32 x 17 inches
Terra Foundation for the Arts,
Daniel J. Terra Collection, 1999.91

Mary Fairchild MacMonnies
Blossoming Time, c. 1901
Oil on canvas
39 x 64 inches
Collection of the Union League Club of Chicago

Will Hickok Low
L'Interlude: Jardin de MacMonnies, 1901
Oil on canvas
19 1/4 x 25 1/2 inches
Bayly Art Museum,
University of Virginia, Charlottesville

Ellen Emmet Rand
Frederick MacMonnies in His Studio, c. 1898
Oil on canvas
21 3/8 x 17 1/2 inches
The William Benton Museum of Art,
University of Connecticut, Storrs